Medieval Cats

Professor Catherine Nappington teaches felinology, the study of cats, at Maine (Coon) University in Maine, United States. She lives with her two tabbies in Portland, a city that has more than 700,000 cats (true fact), and is the cat-lady capital of America. She doesn't get out much.

For my cats, Indie and River.

Published in the United States by Ten Speed Press, an imprint of the Crown Publishing Group, a division of Penguin Random House LLC, New York.
TenSpeed.com

Ten Speed Press and the Ten Speed Press colophon are registered trademarks of Penguin Random House LLC.

Published by arrangement with Quercus Editions Limited. First published in the United Kingdom in 2024 by Greenfinch, an imprint of Quercus Editions Ltd, Carmelite House, 50 Victoria Embankment, London EC4Y 0DZ. A Hachette UK Company.

Library of Congress Control Number: 2024943728

Hardcover ISBN: 978-0-593-83750-4
Ebook ISBN: 978-0-593-83751-1

Printed in China

Acquiring editor: Kim Keller | Production editor: Liana Faughnan
Designer: Francesca Truman | Art director: Betsy Stromberg
Production designer: Mari Gill
Production manager: Serena Sigona
Proofreaders: Sibylle Kazeroid and Robin Slutzky
Publicist: David Hawk | Marketer: Brianne Sperber

10 9 8 7 6 5 4 3 2 1

First US Edition

Cover art © by Siripak / Adobe Stock

Medieval Cats

Claws, Paws, and Kitties of Yore

Professor Catherine Nappington

TEN SPEED PRESS
California | New York

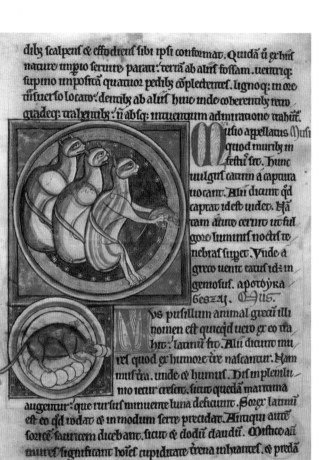

dib scalpens & effodiens sibi ipsi conformat. Quidā ū ex huī
nature impio seruire parati: terrā ab aliis fossam, uentriq;
supino imposita quatuor pedibz cōplectentes. lignoq; in me
tisuerso locato: dentibz ab aliis huic inde coherentibz reu
gradens: trahentibz: ñ absq; intuentium admiratione trahūt.

Musio appellatus Musi
quod muribz in
festui sit. hunc
uulgus catum a captura
uocant. Alii dicunt qd
captat idest uidet. Hā
tam auite cernit ut ful
gore luminis noctis te
nebras super. Vnde a
greco uenit catus idem in
geniosus. apotoyka
beszai. Mus.

Vs pusillum animal greci illi
nomen est quicqd uero ex eo tra
hit: latini sit. Alii dicunt mu
res quod ex humore tre nascantur. Ham
mus tra, unde & humus. His implenilu
nio recur crescit, sicut quedā maritima
augentur: que rursus minuente luna deficiunt. Sorex latini
est eo qd rodat & in modum serre precidat. Antiqui aute
sorice sauricem dicebant, sicut & clodū claudū. Mistice aut
mures significant hoies cupiditate trena inhiantes. & prelā

A clowder of cats, and a rat feeding on eggs, Bestiary, with extracts
from Giraldus Cambrensis on Irish birds, *Harley 4751, f.30v,*
13th century. From the British Library archive/Bridgeman Images.

YE OLDE CONTENTS

INTRODUCTION

The Middle Ages. What a fun time to be alive! It was an era of sieges and superstition, bloodshed and bloodlines, conquest and chaos. Between 500 and 1500 CE, mythical megastars such as Robin Hood and King Arthur rubbed muddy metaphorical shoulders with real-life legends such as Leonardo da Vinci and Joan of Arc, to name just two heroes of history. It was also a time before cutlery, underwear, and flushable toilets, and, boy, does it show. If the medieval ages were a modern Hollywood movie, critics would call it "the bloodiest action-mystery-thriller-fantasy-horror-romance-drama ever made," with a thousand-strong cast of lunatics, heretics, shamans, pagans, witches, warlords, and dictators too unbelievable to lead the way—but who most certainly did. It was a wild, wicked, and weird time, no doubt. It comes as little surprise that nobody got out of it alive.

At the heart of all this mayhem, there was a horse-and-cartload of curious medieval cats bearing witness—when they weren't napping in a nice warm

spot, of course—to a rather epic thousand years of human misadventure. However, cats did more than just simply observe our shenanigans. They became integral to them (though not by choice). We squeezed them into our storytelling, our superstitions, our sin—even our language—almost as soon as the Dark Ages kicked in. At first, these domestic pets simply kept the rodents in check before being elevated to valued status symbols, creatures we allowed to pounce playfully across the parchment of important manuscripts, their antics recorded with joy by their narrators. Alas, as the medieval age evolved across Europe, cats soon transmogrified into agents of evil in league with the devil, condemned to live their nine lives as mere puppets of sorcerers, according to the stupid and superstitious. (Cats work for no man, not even the Dark Lord; anyone who's ever met a cat knows that!) We can laugh about it now, but the end of the medieval era was not cool for cats. Thankfully, they landed on their paws and are now pretty much adored all over. As for humans, the jury's still out.

Anyway, welcome to this curious compendium that goes seriously medieval on cats. Inside, you'll find a catalog of frisky felines from ye olde times of yester yore getting up to all sorts of fun— and a whole lot more. Now tell me, which medieval cat is *your* favorite?

7

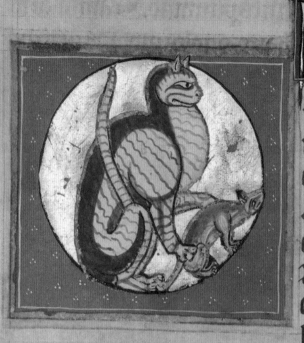

usio
iatur
mur
infestus fit.
uulgus cat
captura uo
Alii dicunt
captat .i. in
ʒ:am tanto
cernit. ut fu
luminis n

tenebras superet. Vñ á greco uento cad .i. ingeñ

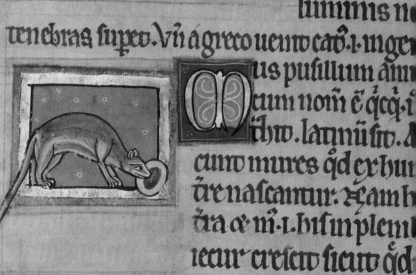

us pusillum añi
cum noñ e q̃ cq̃ i
itho. latinũ fit. A
cuto mures q̃d ex hui
tre nascantur: ʒ:am h
tra & m .i. his in plenu
iecur cretero sicut q̃d

1.

THE CATT SATTETH UPON THE MATTETH

 edieval cats of all shapes and sizes strayed and sprayed the world for more than a millennium in the humble hope of finding a good home in which to nap on a nice warm lap. Because medieval cats loved nothing more than staying out of trouble, after all. Well, sort of . . .

"I am a most faithful watchwoman, ever-vigilant in guarding the halls; in the dark nights I make my rounds of the shadowy corners—my eyes' light is not lost even in black caverns. Though I am a roving huntress and will pry open the dens of beasts, I refuse to pursue the fleeing herds with dogs, who, yapping at me, instigate cruel battles. I take my name from a race that is hateful to me. What am I?"

"Riddle No. 65," Aldhelm, Abbot of Malmesbury
(a famed medieval riddler), Wiltshire, 700.

The answer is a "mouser"—
a medieval way of saying "cat."

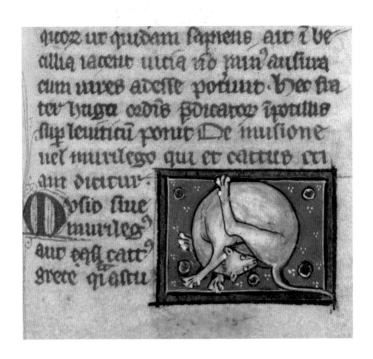

"Bum's out, tongue's out!"

Kitty lick, Bibliothèque municipale, MS 320,
f.73, Valenciennes, France, 1280.

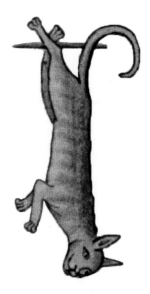

"Didn't think this through, did I?"

Upside-down cat, The Tudor Pattern Book, *Bodleian Library MS. Ashmole 1504, f.32v, 1464. © Bodleian Libraries, University of Oxford.*

"Cursed be the pesty cat that urinated
over this book during the night.

And beware well not to leave open books
at night where cats can come."

One morning in 1420, a Dutch monk found his
beautiful manuscript ruined by cat wee. The monk
was so annoyed, he drew a picture of the cat and
cursed it on the page—for all eternity to see.

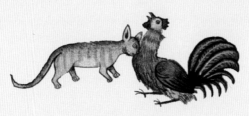

"Cock-a-doodle-dinner."

"Unless need compels you, my dear sisters, you must not keep any animal—except a cat. Now, if someone needs to keep one, let her see to it that it does not annoy anyone or do any harm to anybody, and that her thoughts are not taken up with it."

Ancrene Riwle, *Anonymous*, 1225.

◇◇

The *Ancrene Riwle* was a code of conduct written by medieval monks for anchoresses, religious hermits, and the original crazy cat-ladies.

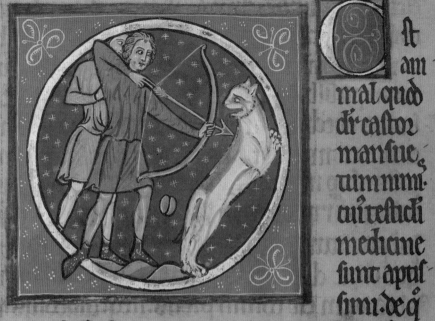

et
am
mal quod
dr castoz
mansue,
tum nimi
tui testidi
medicine
sunt apus
simi. de q̃

oicit phisiologus. quia cum uenatozem se m
sequitem cognouit: morsu testiculos s abscidit.

"I'd love a back scratch, thanks!
Oh, wait . . ."

Close-range cat attack, St. John's College MS 61, f.12v, c. 1200.
© The President and Fellows of St. John's College, Oxford.

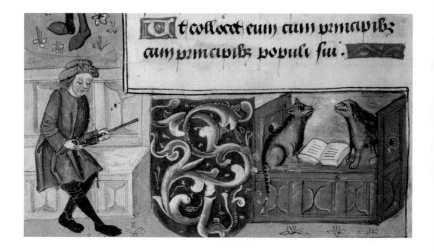

t collocet eum cum pricipibz
cum pricipibz populi sui .

"What do you call a book full of kitties? A catalog!"

Book lovers, Bibliothèque municipale, MS 0016,
f. 023v, Abbeville, France, 1475–1499.

Pangur Bán

The most famous feline love letter that survives from
the medieval period is the poem by Sedulius Scottus,
an Irish monk in exile, about his white spotted cat,
Pangur Bán, c. 900. In the poem, Scottus playfully
compares his daily chore to that of his mouser.

I and Pangur Bán my cat,
'Tis a like task we are at:
Hunting mice is his delight,
Hunting words I sit all night.

So in peace our task we ply,
Pangur Bán, my cat, and I;
In our arts we find our bliss,
I have mine and he has his.

All domesticated cats descend from one genetic ancestor, *Felis silvestris lybica*, from one common location: Africa.

"I am your king. Bring food."

If looks could kill, Nicolaus de Lyra super Bibliam, *Italy, Latin MS 162, f. 252v, 1402. Image provided by the John Rylands Research Institute and Library, the University of Manchester.*

ebus uo n hnt n ip iste
ebz i prellu . Sar g qy ps
ib ur pz tuieu . pz qdic ra
destruy teplum vz . llplin
tuauit sic sciat ps o nabus
lu testiiz a pz cuptiuerut
ie teplu; re edisicaibz a iu
v zgabuf . sz h e sz cero
ps iste pt evpoi de afflute
io mlta unde siint i sscia er
antichzi illustro pz c tyria
su ctr av mo trs a adalia
atatibz a iuu . ut hz . i . mach
tiate siint subleuati per
te reupauint a ifideles de
des dd inspu sci lz pe q di
ctozu a spa antichzi mali
celo . pspz . z . debite pe . l . No
n mia i . go dabit . Cep
ous u e ics qz cultu tei uci

ossa collisa . a tio misabilr mo
fusi sz qn to spirt cco . i qn e fi
a do i misso . qz ci sotoze ecrat g
may osusio sci i toti cratu .
libato crdi mia . ilo dd p mo o
rum lz libatois . d . qo dabit cu
uistratibz iteplo qz crat i mi
remediuz 5 antichu a ci cerat
qn to dedit ostatia a audatia i
pugno pzip . q mathauas siint
qz sur i cer . ut hz . p . mach . zo . C
sue i ductu p antichu . exltab
siint qu iudas machabe a iplo
uitate mudauer teplu re edi
rentes c gaudio mag . ut hz p
sni e leti impz mag ualte . O
uioze i mal suis obstiuaro q lz
ti sius . sz r apli ao tytu . p . Cosu
uegzir . d mali to exaiuar a piz
cipit ihc snie de sali ositatis pti

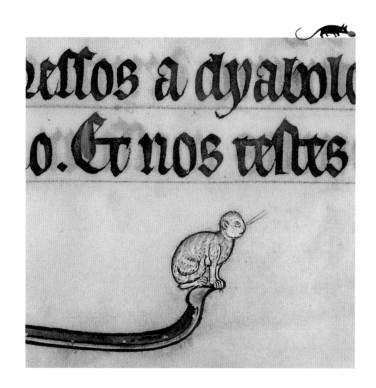

"Be quiet as a mouse . . .
then POUNCE!"

A cat prepares to leap, MS 190, f.72r,
Cambrai Bibliothèque municipale, France, 1266.

"Let's take a cat, and feed him well with milk
And tender flesh, and make his couch of silk,
And let him see a mouse go by the wall,
Then he waives milk and flesh and all,
And every dainty that is in that house,
Such an appetite he has to eat a mouse."

"The Manciple's Tale," The Canterbury Tales, *Geoffrey Chaucer, on cats as mousers, c. 1400.*

The tradition of black cats symbolizing bad luck began in the medieval era. One particularly silly strand of superstition stated that if a black cat walked toward you, it was good luck . . . but if it walked away from you, it took the good luck with it—and left you with none!

"The cat is called musio, mouse-catcher, because it is the enemy of mice. Others say it gets the name from *capto* because it catches mice with its sharp eyes. For it has such piercing sight that it overcomes the dark of night with the gleam of light from its eyes. As a result, the Greek word *catus* means sharp, or cunning."

Origin of the word "cat," The Aberdeen Bestiary, *1200.*

"Sorry, Jesus, but my bum's not gonna clean itself!"

Christ in Majesty (while a cat licks its bum), MA 112, f.7r, Germany, 1440–1460. From the New York Public Library.

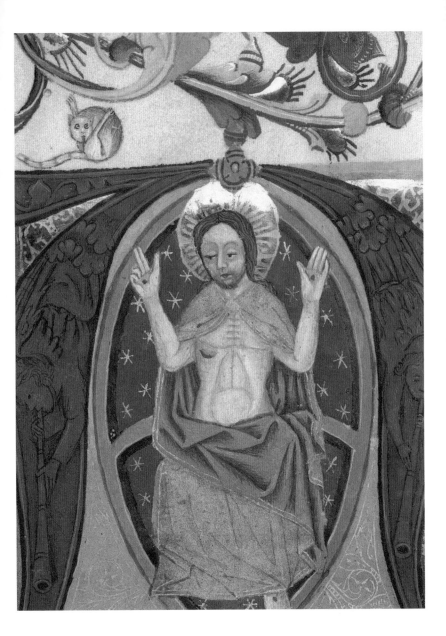

"Wow! This stuff is *strong.*"

Cat super high on catnip, De natura animalium, MS 711,
f.23r, Bibliothèque municipale, Cambrai, France, 1270.

"I wept and I wayled
The tearys downe hayled;
But nothinge it avayled
To call Phylyp agayne,
Whom Gyb our cat hath slayne."

The Book of Philip Sparrow, *John Skelton, 1525.*

John Skelton's famous poem is about a young woman attending mass at a church in Norwich, England. Instead of praying, however, she's thinking only about the brutal death of her pet sparrow, Philip, killed by Gyb, her cat.

"They mutter with their teeth closed and they feel in the dark toward where they saw their Lord and, when they find it, they kiss it, the more humbly depending on their folly, some on the paws, some under the tail, some on the genitals."

De Nugis Curialium, *I.30, Walter Map, Archdeacon of Oxford, 1180.*

Medieval writer Walter Map on *osculum obscenum* (kissing a cat's anus), a ritual for worshippers of the devil, who would disguise himself on Earth as a black cat.

"I'm not fat! I'm cuddly!"

*Fat cat, detail from a bestiary, England, MS 379, f.12r,
14th century. © Fitzwilliam Museum/Bridgeman Images.*

egredimini filie syon z videte regē sa lomonem in diademate qua corona uit eum mater sua in die dispensatiōis illius in die leticie cordis eius. Deo grãs.

"Did you hear about the cat who swallowed a ball of wool? She had mittens!"

Cat on drums, from a marginal cycle of images of the funeral of Reynard the Fox, Book of Hours, MS W.102, fol. 78v 1, 1300. From the Walters Art Museum, Baltimore.

"Thou shalt not suffer a cat to live."

Pope Gregory IX

◊◊

On June 13, 1233, Pope Gregory IX, head
of the Catholic Church, declared all cats,
particularly black ones, demonic.

The widespread massacre of cats that followed in
Europe helped spread the Black Death, a pandemic
that killed more than 200 million people.

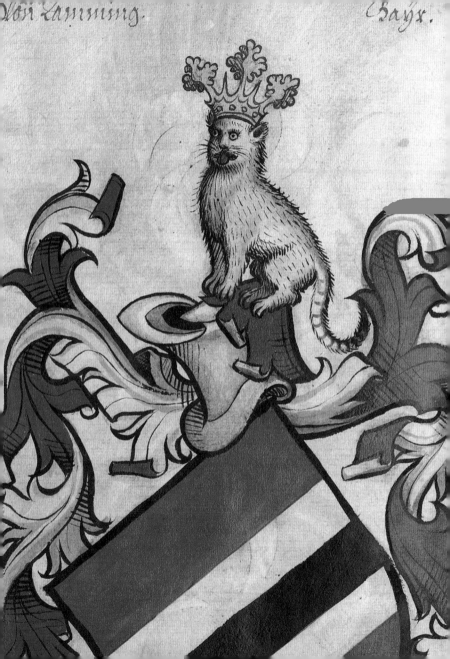

2.

KING CATTUS

For the first part of the medieval era, in the Dark Ages, cats were kings. They ruled the lands they roamed and partied with monks, priests, and the ruling elite. Even kings and queens bowed down to cats to give them a cuddle. That's power you just can't buy.

All hail the one true king—King Cattus!

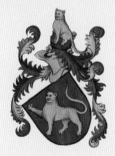

"A cat may look at a king."
A cat proverb from the 1500s meaning that even the lowest creature still has rights.

The Cat King, Scheibler'sches Wappenbuch, BSB Cod.icon.312, p. 263 (opposite) and p. 49 (right), 1450. © Bayerische Staatsbibliothek, München.

King Solomon's Cat

This popular medieval fable told tall tales of
the last king of Israel, King Solomon, and his
wise cat, a kitty so magical that it would hold a
candle at the dinner table while the king dined.

The tale of *King Solomon's Cat* was first
recorded in 1450 by Hans Vintler.

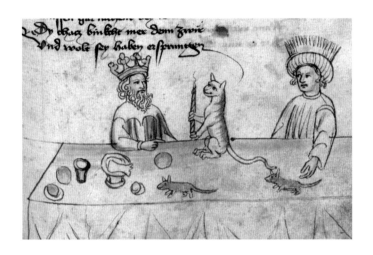

"All together now . . .
'Cat and the candle and
the silver spoon . . . '"

King Solomon's Cat, Die Plümen der Tugent, *Hans Vintler, cod. s.n. 12819, f.130r, Wien Österreichische Nationalbibliothek, 1450.*

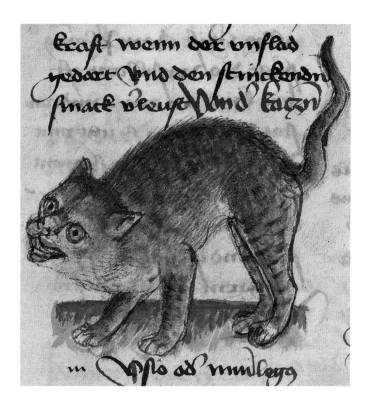

"Look what the cat dragged in —ME!"

Mad moggy, Buch der Natur, Konrad von Megenberg, MS.2.264, f.85r, 1434. Bibliothèque nationale et universitaire de Strasbourg, France.

Ireland's Witch

In 1324, Alice Kyteler became the first person condemned for witchcraft in Ireland. She is said to have summoned a demon that took the form of a black cat to help her poison all four of her husbands.

Kyteler escaped during her trial, so her servant, Petronilla de Meath, was burned to death at the stake in her place.

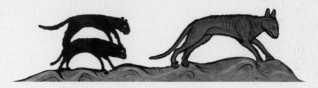

"This is harder than it looks!"

Tybert, King of Cats

In medieval France, pet cats were called Tybert—the origin of the English pet name "Tiddles." The name Tybert rose in popularity due to the French folklore tales of Reynard, the trickster fox, who would often play pranks on his feline companion, Tybert.

The earliest mention of Tybert as the "King of Cats" dates back to 1481.

Cat Fact #1

Other common pet names for medieval cats that have survived in manuscripts include Mite, Belaud, Meone ("little meow"), Cruibne ("little paws"), and Breone ("little flame," no doubt for ginger cats).

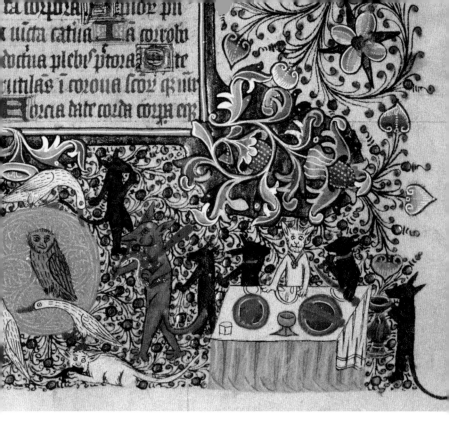

"May the Dark Lord make us able
To eat all the mice on the table. Amen!"

*Cat dinner party, MS. Laud Misc. 302, f.210r,
mid-15th century. © Bodleian Libraries, University of Oxford.*

"I'm going to Hell for this."

A cat cosplaying as a nun, Book of Hours, Horae beatae
Virginia Mariae ad usum Romanum, cum calendario, *096
R66HF, folio 99r, State Library Victoria, Australia, 1490.*

Medieval Cat Proverbs #1*

In a cat's eye, all things belong to cats.

A cornered cat becomes as fierce as a lion.

A cat has nine lives. For three he plays, for three
he strays, and for the last three he stays.

Curiosity killed the cat, satisfaction brought it back.

*The Middle Ages practically invented the cat proverb.

Kattenstoet

The origins of Kattenstoet, or the "Cat Parade,"
a Belgian festival devoted to the cat, are very
macabre. For centuries, every year on the second
Sunday of May, a dozen cats were thrown from
the tall belfry tower of Ypres's Cloth Hall to
purge the town of evil spirits contained within
cats. The last cat to take flight was back in 1817.

"Half cat, half goat, half asleep."

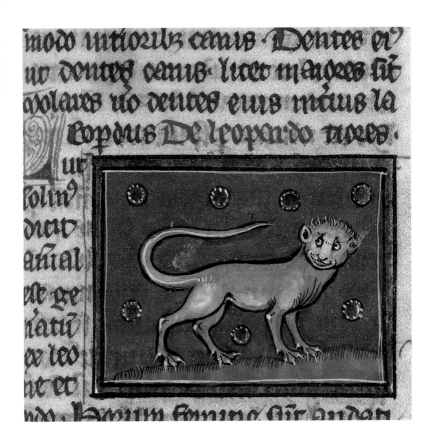

"Call me Sir Claws-alot."

Cheshire grin on a gray leopard, MS 320, f.67, Bibliothèque municipale, Valenciennes, France, 1280.

"The catnip's kicking in . . .
I've got The Fear."

*Wild eyes, The Hague MMW, 10 B 25 f. 24v and 65v, 1450. From
the Koninklijke Bibliotheek National Library of the Netherlands.*

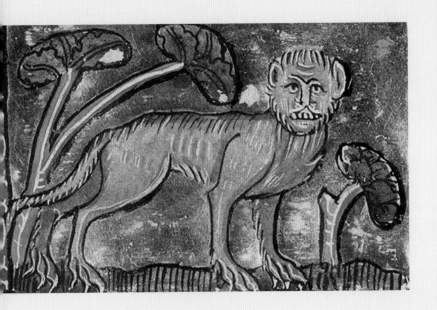

"Stroke me and you die."

Top cat, The Hague MMW, 10 B 25 f. 24v and 65v, 1450. From the Koninklijke Bibliotheek National Library of the Netherlands.

In 945, Welsh King Hywel Dda (above) valued
cats so much, he established laws that set out the
duties of the cat and its monetary worth:

"The value of a cat, fourpence. The value of a kitten
from the night it is born until it opens its eyes, a legal
penny; and from then until it kills mice, two legal
pence; and after it kills mice, four legal pence."

"You're not riding me.
I'm carrying you. Got it?"

Cat carrier, Speculum historiale, *Vincent of Beauvais, MS. 130I, f. 233r, Bibliothèque municipale, Boulogne-sur-Mer, France, 1294–1297.*

"Nice to eat you, mouse!"

Cat who got the cream, Melchiorre Sessa, *University of Pennsylvania Libraries, Philadelphia, United States*, C5 Al116 5320, 1506, 1533, and 1543.

Raining Cats and Dogs

Some believe this famous medieval phrase has
its origins from when ye olde English rainstorms
were so big that people would float the bodies of
dead animals (of which there were a lot) in the
rivers of rainwater washing down the streets.

"Hark, how she storms!
She is like to drown me in a shower of cats and dogs."

Petruchio, The Taming of the Shrew,
William Shakespeare, Act 2, Scene 1, 1623.

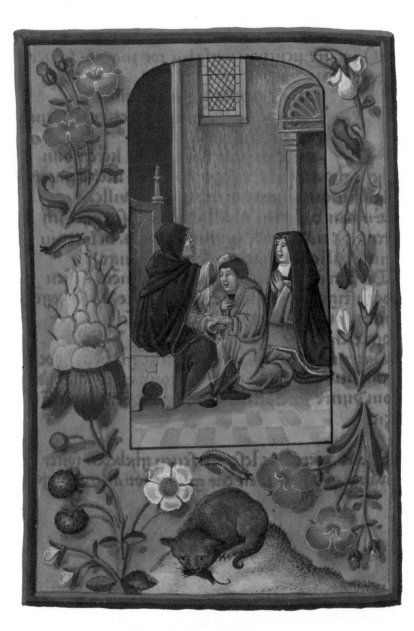

3.

GET THEE TO A CATTERY

Cats were beloved by most servants of God—when they weren't being tortured by fundamentalists or burned alive by superstitious Satanists, that is. It was the monks, after all, who studiously captured the spirit of cats on the pages of their illuminated manuscripts, the comprehensive records of these strange times. . . .

Jacob claims his brother's birthright while a cat snacks on a rat, Book of Prayers, MS Add. 20729, f.105v, Netherlands, c. 1500. From the British Library archive/Bridgeman Images.

William Shakespeare's Cat Lover #1

The world's greatest writer mentioned cats more than forty times in his plays. The mentions were rarely positive.

◇◇◇

"I am as vigilant as a cat to steal cream."
Falstaff, Henry IV, Part I, *Act 4, Scene 2, 1597.*

"Good king of cats, I want to take one of your nine lives."
Mercutio, Romeo and Juliet, *Act 3, Scene 1, 1595.*

"What though care killed a cat? Thou hast
mettle enough in thee to kill care."
Claudio, Much Ado About Nothing, *Act 5, Scene 1, 1598.*

"I could endure anything before but a cat, and
now he's a cat to me. . . . A pox upon him!
For me, he's more and more a cat."
Bertram, All's Well That Ends Well, *Act 4, Scene 3, 1603.*

atteg stercus & sinapem equis ponderibz exacceto
conttricu captus allopicias sanat. Dptluyio ex
partu. Catte stercus cu resina & rosa subpositu
reprimit. iqus spina Glytt ertt·ε̃ spina

Catte stercus illinitu faucibz · sine difficultate excchit

D QVARTANAS. Catte stercu cu ungula bouina
incollo uel brachio suspensu · quartana post septima ac
cessione discutit. sed uide ne festines illud soluere.

D Grille ad Qvi paralisi temptantvr

Grillis adeps remediu afferet· his qui paralisi itemptant.

D claritatem oculorvm.

Grillis exsoriceis combustiones coz melle miscant & inde

"One lick, two lick, three lick,
PAW!"

Cat licks its paw, Herbarium. Ex herbis femininis (extracts)
Liber medicinae ex animalibus, *MS. Bodl. 130, f.90v,*
1090. © Bodleian Libraries, University of Oxford.

len repaira a la gent ki grant
pleme de lor anemis auoient
ocis. Et li remanans sen estoit
fuis. Li romain reuindrent a
grant ioie a lor tentes. Coment

Cesar en
tra en la
terre de
sens ?
Cesar tu
puis ve
ne gu͠t

"Cats are a mysterious kind
of folk. There is more passing
in their minds than we are
aware of. It comes no doubt
from their being so familiar with
warlocks and witches."

Sir Walter Scott, Scottish poet and historian, c. 1800.

"Jump . . . and I'll give you
paws for thought!"

*Cat teasing dog, Book of Hours (Thérouanne), Chronique
de Baudouin d'Avesnes, MS. 1043 (863) f.69r, Médiathèque
de l'Abbaye Saint-Vaast, Arras, France, 13th century.*

"Cats are not impure, they keep watch about us."

Muḥammad (570–632), the medieval prophet of Allah and founder of Islam, was famously a fan of cats. It is believed that he had a favorite cat, Muezza, whom he loved so much he would rather be without his garments than disturb the cat when she was sleeping upon them.

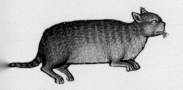

"Don't mind me. Just looking for a warm spot."

54

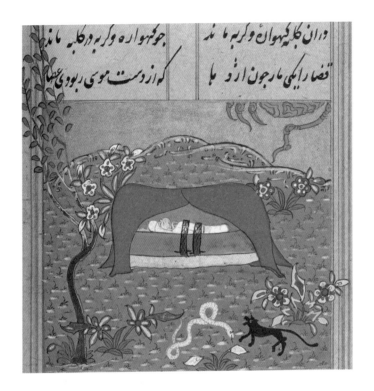

"How can I trust you? You're a snake in the grass!"

Cat protects a sleeping baby, Sinbadnama: The Story
of Sinbad, *I.O. ISLAMIC 3214, f.64v, c. 1575. From the
British Library archive/Bridgeman Images.*

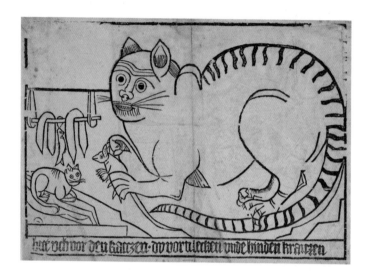

"Whoa! These mice were spiked!"

Cat regrets its catch, woodcut, c. 1500, unknown artist, Cooper Hewitt Smithsonian Design Museum, Wikimedia.

Hüte dich vor den Katzen,
die vorne lecken und
*hinten kratzen.**

(Beware of the cats that lick the front and scratch the back.)

**This German proverb has been attributed to the Protestant*
reformer Martin Luther, during the late Middle Ages.

Transmogrification

The black cat was the perfect vessel for Satan
to be a devil in disguise. When he was, he took
the name Grimalkin—the devil-cat.

"This kitten of ours is a cheeky little monkey!"

Monkey business, Trivulzio Book of Hours, *Royal Flanders, France,
1470. From the Library of Congress, World Digital Library.*

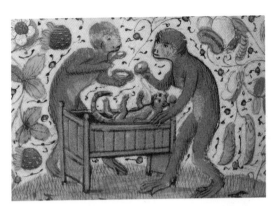

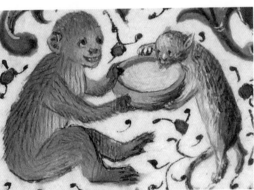

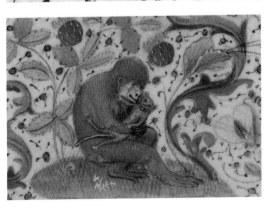

...recte ipos...

ylid in eth. a
micus. q. animi
ut custos ami
citie p diuinatio
nem dns. Et
ppne amicus
gena caritans
. Non sunt fide
lios anim gra
cito deserunt.

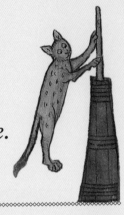

Ou chat na rat regne.

(Where there is no cat, the rat is king.)

The famed proverb "When the cat's away, the mice will play" is taken from the French iteration above, and first appeared in England in the 1470s.

"Scratch—and sniff!"

Butt attack, Rothschild Canticles, Beinecke MS 404, 107v, 130r, 156v, 181r, 1300. Beinecke Rare Book & Manuscript Library, Yale University.

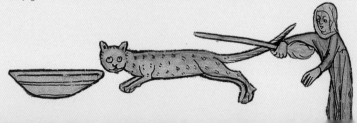

"A cat is worth three cows if it is able to purr and keep its owner's house, grain store, and kiln free of mice, but only half that if it is just good at purring."

The Book of Kells, *Dublin, Ireland, c. 800.*

Ireland's most famous illuminated medieval manuscript, *The Book of Kells,* has a whole section on kitties called the *Catslechtae.* It outlines the medieval code of conduct for owning a cat.

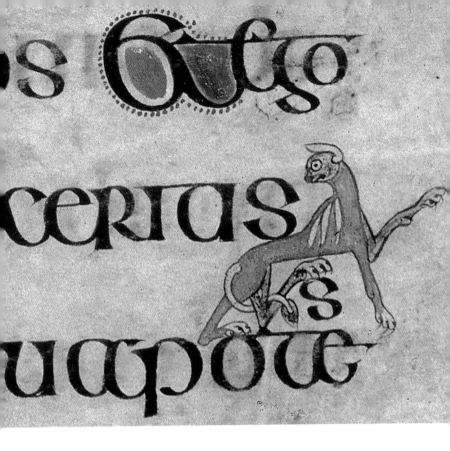

"I haven't slept in at least twenty minutes. I'm off for a nap."

Wide-eyed cat, from the Catslechtae, The Book of Kells, MS58, 183v, 048r. 076v, c. 800. From the Library of Trinity College Dublin, the University of Dublin.

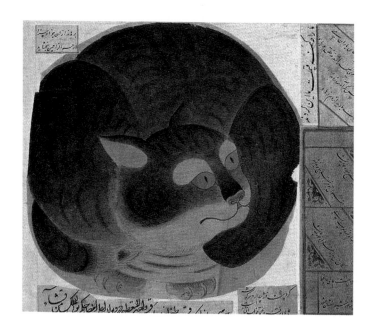

"I'm all curled up
with nowhere to go."

A big ball of beautiful fur, Siyah Kalem School,
15th century. From History/Bridgeman Images.

Belling the Cat

The famous twelfth-century folklore fable "Belling the Cat" tells the tale of three wise mice who decide to tie a bell around a cat's neck so that they can hear it ahead of its attack. However, the mice cannot agree on which one of them should carry out the task, and so the cat remains a threat. The moral of the story? Mice are stupid.

Paw Print

In 2013, while researching his PhD in the Dubrovnik State Archives, medieval scripture student Emir Filipović noticed several paw prints on the page of an Italian manuscript dated March 1445. Filipović's photos of the manuscript went viral on social media and remain hugely popular to this day.

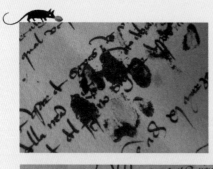

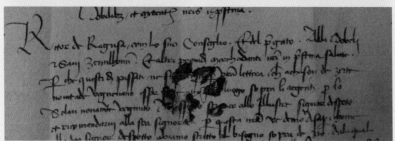

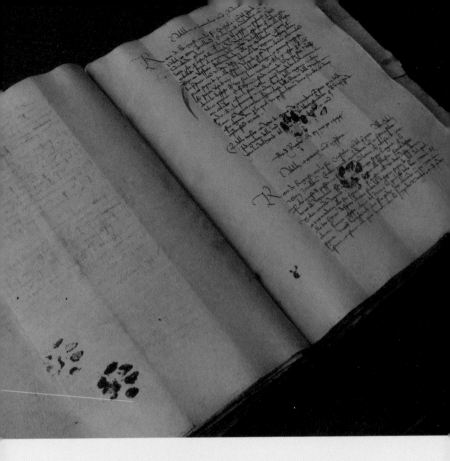

"It wasn't me—it was the dog!"

Inky paws, "Lettere e commissioni di Levante," Italy, 1445.
© Emir Filipović/Dubrovnik State Archives.

Est bestia
que dicit
eale mag
nus ut equus cau
da elephanti. in
gro colore. maxill
a primis. cornua
preferens ultra
modum longa ad
obsequium cuius uelit motus accomoda
ta. Hec enim rigent. sed mouentur ut
usus exigit presiandi. quorum alterum
cum pugnat preten dit. alterum replicat.
ut si ictu aliquo alterius acumen offende
rit acies succedat alterius.

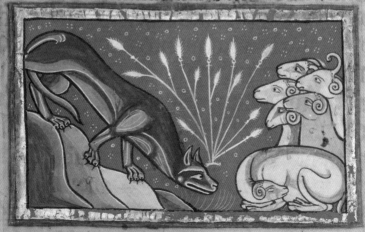

4.
MEOW & THEN

hroughout history, cats have endured an inconsistent relationship with people. In ancient Egypt, cats were idolized by humans as gods. In the Middle Ages in Europe, cats were demonized by humans as devils. Cats have not forgotten either, and so now they behave accordingly. . . .

Creeping cat, bestiary, St. John's College MS 61, f.21r, c. 1200.
© The President and Fellows of St. John's College, Oxford.

"Those who play with cats must expect to be scratched."

Miguel de Cervantes, Spanish novelist, c. 1580.

"So, a cat, a priest, and a monkey walk into a bar . . ."

Cat walks with a priest, Marco Polo, MS. Bodleian 264, f.96r, 1338. © Bodleian Libraries, University of Oxford.

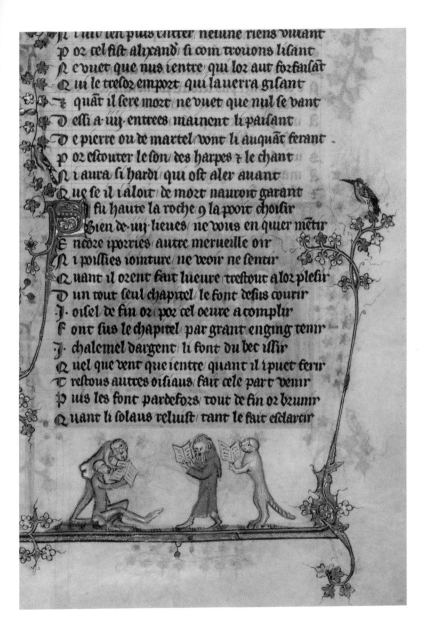

il ſuit len plus entier / neſune riens viuant
p oz cel fiſt alixandr / ſi com trouons liſant
ſ e vuet que nus ientre / qui loz aut forfaiſãt
Q ui le treſoz emport / qui la uerra giſant
z quãt il ſere mozt / ne vuet que nul ſe vant
D eſſi a .iiij. entrees / mainent li paiſant
D e pierre ou de martel / vont li auquãt ferant
p oz eſcouter le ſon / des harpes z le chant
N i aura ſi hardi / qui oſt aler auant
Q ue ſe il i aloit / de mozt nauroit garant
ſi fu haute la roche / g la poit choiſir
B ien de .iiij. lieues / ne vous en quier mẽtir
E ncoze iporries / autre merueille oir
N i poiſſies iointure / ne veoir ne ſentir
Q uant il ozent fait luevre / treſtout a loz pleſir
D un tout ſeul chapitel / le font deſus couvrir
J . oiſel de fin oz / poz cel oevre acomplir
F ont ſus le chapitel / par grant enging tenir
J . chalemel dargent / li font du bec iſſir
Q uel que vent que ientre / quant il i puet ferir
T reſtous autres oiſiaus / fait cele part venir
p uis les font pardefozs / tout de fin oz bzuiꝛ
Q uant li ſolaus reluiſt / tant le fait eſclavcir

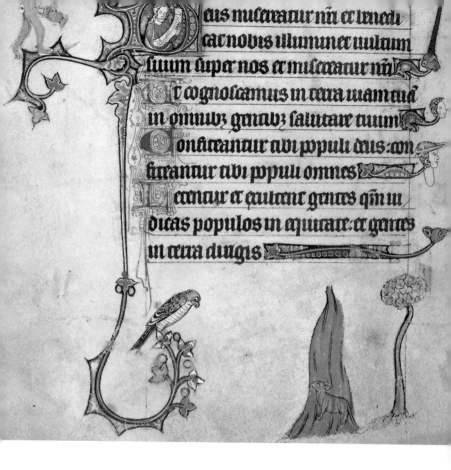

"You sure look a lot like
my dinner tonight."

Cat eyes its food, Book of Hours (Rome), *Cambridge MS B. 11.22, f.092v,
1300. From the Master and Fellows of Trinity College, Cambridge.*

"He is a right heavy beast in age and full sleepy, and lieth slyly in wait for mice: and when he taketh a mouse, he playeth therewith, and eateth him after the play. And he maketh a ruthful noise and ghastful, when one proffereth to fight with another: and unneth is hurt when he is thrown down off a high place."

Bartholomaeus Anglicus, on cats, De proprietatibus rerum (On the Properties of Things), *1240.*

Bartholomaeus's *De proprietatibus rerum* was the first printed encyclopedia and was widely cited in the Middle Ages. It is the most important compendium of medieval knowledge for scholars today.

Medieval Cat Proverbs #2

It takes a good many mice to kill a cat.

Cuirm lemm, lemlacht la cat.
(Beer with me, fresh milk with a cat.)
Irish

Make yourself a mouse and the cat will eat you.

Whenever a rat teases a cat, he is leaning against a hole.

A cat is a lion in a jungle of small bushes.

Aussi aise que ung chat qui ce baingne.
(As comfortable as a cat in a bath.)
French

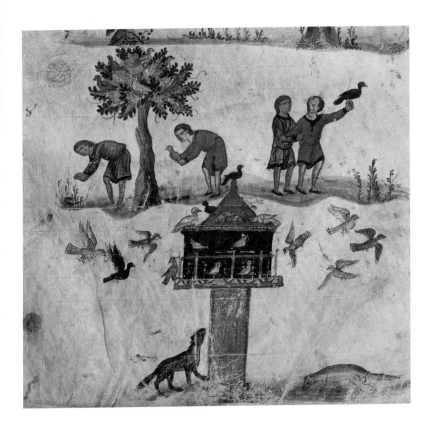

"Eeny, meeny, miny . . . moe!"

A cat among the birds, De Venatione, *a Greek
treatise on hunting, 11th century. © A. Dagli Orti/
© NPL—DeA Picture Library/Bridgeman Images.*

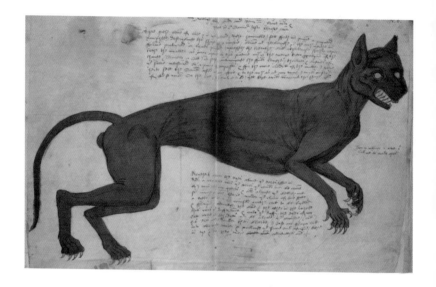

"Scratch me if you can!"

Monster cat, supposedly spotted on February 18, 1568,
Leicester, drawing by the Commissary of the Ecclesiastical
Court for the Earl of Huntyngdon, Lansdowne MS 101/6, 1568.
From the British Library archive/Bridgeman Images.

King Arthur's Quest

The giant devil-cat of Arthurian legend, Cath Palug (the Clawing Cat, in Welsh), roamed the Isle of Anglesey, Wales, until King Arthur himself went on a quest to kill the horrible beast. In the battle, Cath Palug licked its claws when they were wet with Arthur's blood. The king was said to have lost an arm in the fight.

The tale was first recorded in the 1200s.

According to medieval superstition, to reverse the bad-luck curse of a black cat crossing your path, first walk in a circle, then walk backward across the spot the cat crossed and count to thirteen. Only then will the curse be lifted.

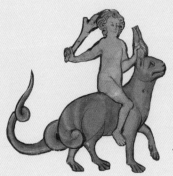

"Could you put some clothes on at least?"

"Quiet! I heard someone open a tin."

Tabby cat, De animalium proprietate, *Manuel Philes, Burney MS 97, f.21, France, 1550. From the British Library archive/Bridgeman Images.*

Domine labia mea

aperies. ꝶ

Et os meum:

"When I play with my cat,
how do I know that she is
not passing time with me
rather than I with her?"

Michel de Montaigne, French philosopher, c. 1560.

"Hello darkness,
my old friend . . ."

Cat plays a lyre, Book of Hours, MS 662, f.21r, 15th century.
Beinecke Rare Book & Manuscript Library, Yale University.

"For the pain and blindness in the eye, take the head of a black cat, which hath not a spot of another color in it, and burn it to powder in an earthen pot leaded or glazed within. Then take this powder and through a quill blow it thrice a day into thy eye. And so shall all pain flie away, and blindness depart although it hath oppressed thee a whole year: and this medicine is approved by many Physicians both elder and later."

Edward Topsell, on his "approved" potion to cure blindness,
The Historie of Foure-Footed Beastes, *1607.*

"Edward, you're an idiot."

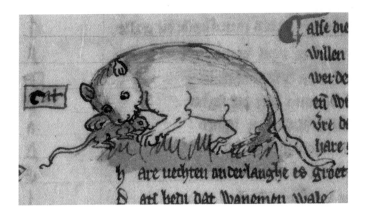

"Mouse, it's not my fault you taste so delicious."

Cat takes a bite, De natura rerum, *Thomas de Cantimpré, MS Add. 11390, f.21, 13th century. From the British Library archive/Bridgeman Images.*

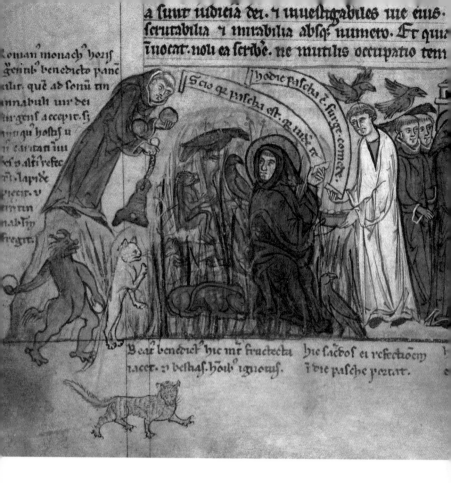

"Time to take a catnap—bonk!"

The devil attacks a cat from behind as another cat looks on, Expositio in Apocalypsim, *Alexander Minorita, MS Mm.5.31 54v, 1249. Reproduced by kind permission of the Syndics of Cambridge University Library.*

"If any beast has the devil's spirit in him without doubt it is the cat, both the wild and the tame."

Edward, Duke of York, 1406.

"Who you calling a beast?"

In ancient Egypt, cats represented a positive symbol of female sexuality, as seen through the depictions of Bastet, the black cat goddess.

Throughout prudish medieval Europe, that positive symbol of female sexuality corroded. The word "puss" arrived in the developing English language around 1533 and described anything that was "soft, warm, and furry." It wouldn't be long before a derogatory term we all know (and loathe) came to describe a woman's genitalia . . . and weak men.

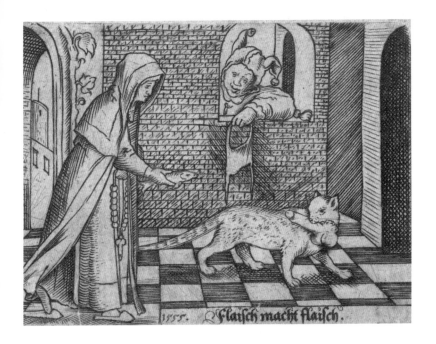

"Get your own damn penis!"

Nun trades fish for penis (Flaisch macht Flaisch; flesh for flesh), woodcut, unknown artist, Netherlands, 1555. From the Rijksmuseum, Netherlands.

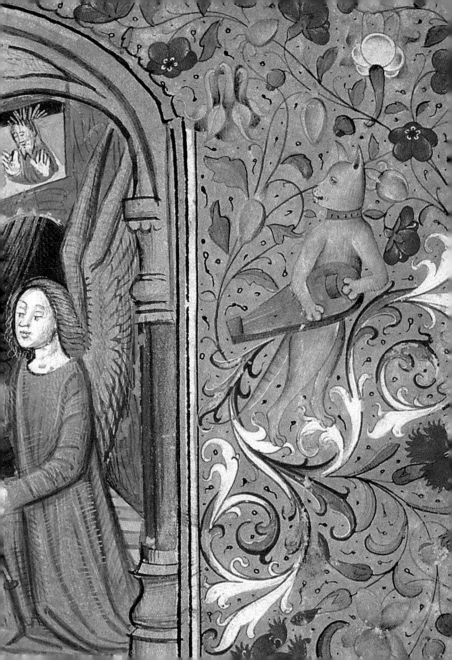

5.

GYBS & GRIMALKINS

ome cats of the medieval era were considered—falsely—to be Satanic spirits of the supernatural realm, more likely to lap up sorcery than a saucer full of cream. They were called grimalkins. Domesticated cats—known as gybs—got the better end of the broom and were loved by those who looked after them.

Cat plays a musical instrument, Book of Hours, *Paris, MA 47, f.29r, 1450. From the New York Public Library.*

"A kitten roves about following the straw; even if you are clever, you will scarcely induce an old cat to this trick."

Egbert of Liège, The Well-Laden Ship (Fecunda ratis), eleventh century.

Egbert's Latin poem was full of ancient and medieval proverbs, fables, and folktales. It also featured the earliest forms of nursery rhymes and fairy tales, including "Little Red Riding Hood."

"Still trippin', man."

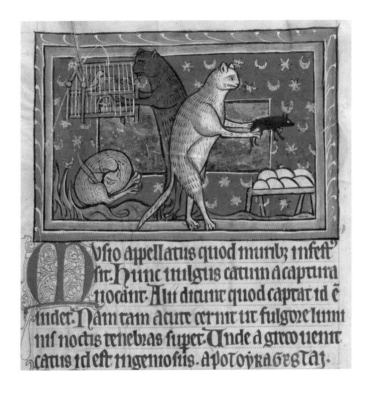

Vsto appellatus quod murib; infest
sit. hunc vulgus catum a captura
vocant. Alii dicunt quod captat id e
videt. Nam tam acute cernit ut fulgore lumi
nis noctis tenebras super. Unde a greco venit
catus id est ingeniosus. ΑΡΟΓΟΥΚΑΘΕϹΤΑϹ.

"I'm armed ... and dangerous."

*Two cats steal a rat while a guard dog snoozes, bestiary, MS. Bodleian
764, f.51r, 1226. © Bodleian Libraries, University of Oxford.*

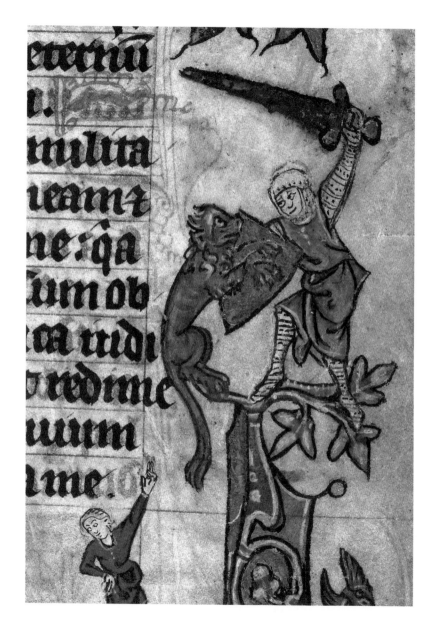

eternu
u.
milita
eam t
ne: qa
um ob
ca tridi
redime
uuum
a me.

"Cat got your tongue?"

Everyone's favorite English idiom, "Cat got your tongue?," dates back to the Middle Ages, when superstitious people believed that a witch's black cat could steal, or paralyze, a person's tongue, leaving them unable to speak.

The phrase has origins in ancient Egypt, when pharaohs were known to cut out a criminal's tongue as punishment . . . and feed it to their pet cat.

"'Tis but a scratch!"

Cat and knight fight, The Maastricht Hours (Netherlands), MS Stowe 17, f.112, 1320. From the British Library archive/Bridgeman Images.

"I will never buy the pig in the poke
There's many a foul pig in a fair cloak."

Thomas Heywood, playwright, c. 1550.

The phrase "let the cat out of the bag" dates back to
the mid-1500s and started life as "a pig in a poke":
something purchased without first being inspected.

At medieval markets, devious farmers would
often trick customers by selling them a cat in a
bag instead of a suckling pig. When the customer
returned home and opened the bag—or poke—the
cat sprang out of the bag and revealed the truth.

"Schrödinger, you crazy cat!"

Cat in a box, De herbis femininis, MS Sloane 1975, f.86v, France, 1275. From the British Library archive/Bridgeman Images.

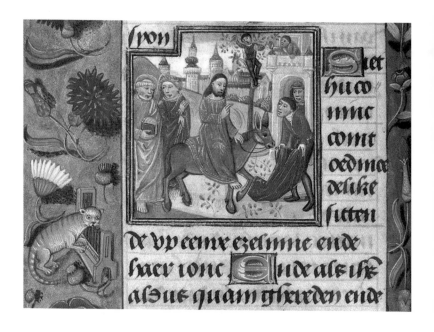

"What's new, pussycat?
Whoa whoa whoa whoa!"

Cat looks surprised by its own musicality, Book of Hours, *Bruges,
W.438, fol. 161v, 1480. From the Walters Art Museum, Baltimore.*

William Shakespeare's
Cat Lover #2

"I am as melancholy as a gib cat or a lugged bear."
Falstaff, Henry IV, Part I, *Act I, Scene 2, 1597.*

"The cat with eyne of burning coal,
Now couches from the mouse's hole."
Gower, Pericles, *Act 3, Scene 1, 1607.*

"But will you woo this wildcat?"
Gremio, The Taming of the Shrew, *Act 1, Scene 2, 1591.*

"Playing the mouse in absence of the cat, to
'tame and havoc more than she can eat."
Bishop of Ely, Henry V, *Act 1, Scene 2, 1596*

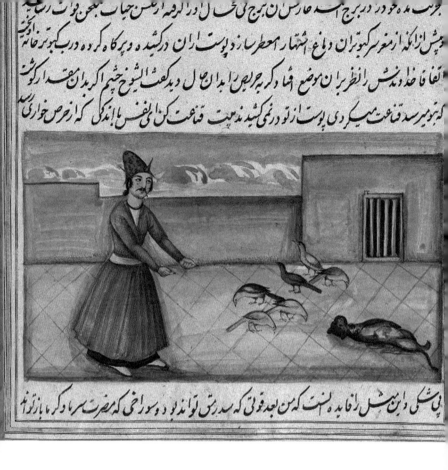

"Don't worry, even a dead cat
will bounce from a great height!"

A greedy cat killed by the owner of pigeons, The Lights of Canopus, *Persia,
MS W.599, fol. 81b, 1264. From the Walters Art Museum, Baltimore.*

"When ye see a cat sitting in a window in the sun and she licks her bottom, and that one of her feet is above her ear, ye need not doubt that it shall rain that day."

Jean d'Arras, on cat ailuromancy, The Gospelles of Dystaues, *1480.*

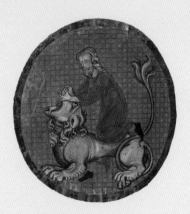

"To the shops, please!"

Ailuromancy
The practice of predicting the
future, especially the weather, by
observing a cat's movements.

This superstition is based in some biological truth.
A cat's supersensitive whiskers can detect a drop
in pressure, an indicator of stormy weather.

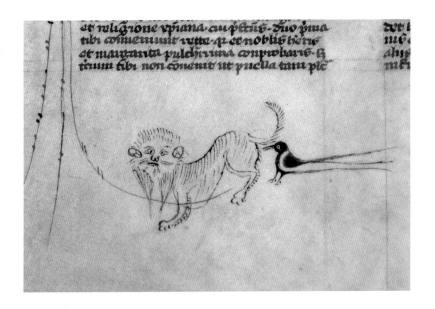

"I smell a rat."

A curious magpie gets up close and personal, Legenda aurea, *Jacobus de Voragine, MS 808, f.88v, Médiathèque Toussaint, Bibliothèque municipale, Angers, France, 1367.*

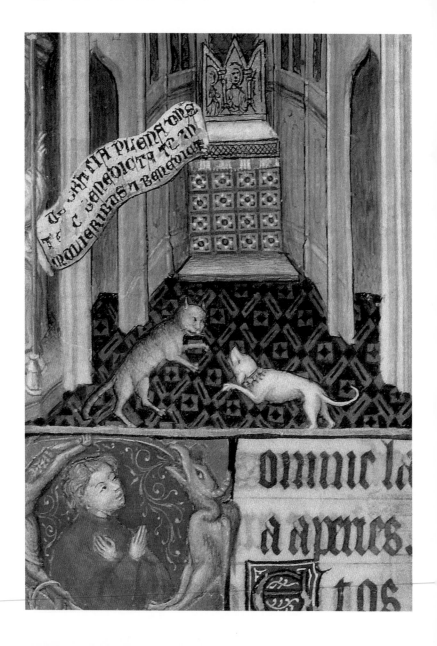

Taghairm

In medieval Scotland, the ritual of Taghairm involved
a person roasting a cat alive above an open flame
and turning it on a spit. As the kitty caterwauled in
pain, the devil would appear. The Dark Lord would
then barter for the cat's life by offering the person
a glimpse into their future. Huge news, if true.

"Feel the pain of my claws, dog!"

A cat and dog fight, Book of Hours, *Paris, MS Add. 29433, f.20,
c. 1407. From the British Library archive/Bridgeman Images.*

Cat Burning

This brutal religious ritual occurred annually in Paris, France, where on the summer solstice, every June 20, Parisians gathered in the thousands at the place de la Grève, a traditional site for execution by guillotine, and watched as dozens of cats were hung above a flaming-hot pyre and roasted alive. Afterward, the king and queen threw a feast to celebrate the cleansing of evil, all while unaware of the irony.

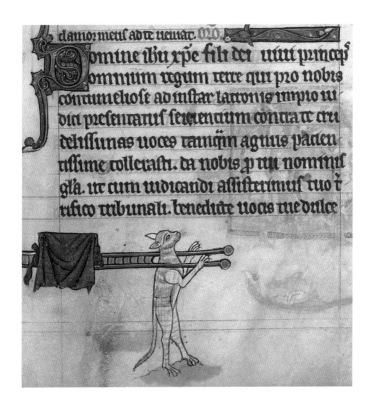

"Not sure we need the ladder. I always land on my paws."

Tybert the Cat carries a ladder for Reynard the Fox, Book of Hours, Paris, W.102.77R, 1300. From the Walters Art Museum, Baltimore.

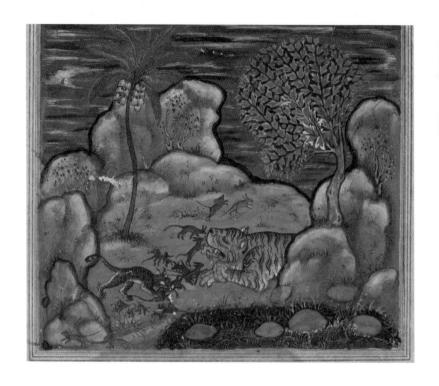

"Go get 'em, tiger!"

A cat attacks the mice that disturb the tiger, The Tutinama (Tales of
a Parrot), *India, 1560. Gift of Mrs. A. Dean Perry/Bridgeman Images.*

Grimalkin, the foul Fiend's cat.
Grimalkin, the Witche's brat.

Medieval rhyme

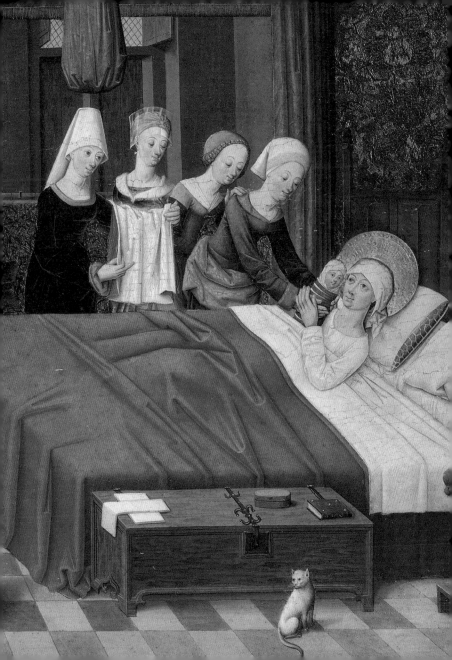

6.

BEWARE THE CATT

Be honest—cats sometimes deserve the trouble they find themselves in. No cat's *purr-fect*, after all. So don't let their cute little furry faces distract you from the truth: cats can be wicked little devils too. . . .

Birth of the Virgin, 1485, panel from Stories from the Life of Mary, *Master of the Aachen Altar, Germany, 1485. © A. Dagli Orti/© NPL—DeA Picture Library/Bridgeman Images.*

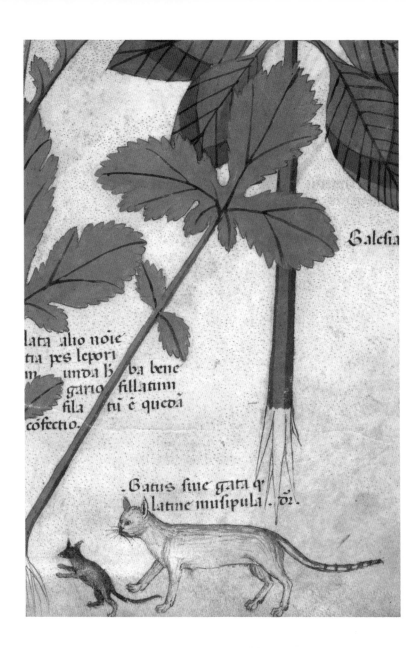

Galesia

lata alio noie
ta pes lepori
m unda herba bene
garic fillatim
fila ti e queda
cofectio.

. Gatus siue gata qr
latine musipula . dr.

Cat at a Cathedral

From 1305 to 1467, Exeter Cathedral, England, officially employed cats as ratters and mousers—and were on the payroll to prove it. The cathedral's accounts of the time showed payments of a penny a week *pro cato* (for the cat) to pay for additional food if the vermin it ate wasn't sufficient. A cathole in the cathedral still exists today and is considered the world's oldest surviving cat flap.

"Fancy a game of Hide-and-Squeak?"

Cat creeps up on a mouse, botanical illustration, MS Sloane 4016 f.40, Italy, c. 1440. From the British Library archive/Bridgeman Images.

Piloerection

The upright raising of hair along the
back of a cat as a response to fear.

"Hair of the dog?
Try hair of the cat!"

*Scaredy-cat, Book of Hours, Paris, Bodleian Library MS. Douce
62, f.139r, c. 1400. © Bodleian Libraries, University of Oxford.*

...q̄uo coʒluum nos merentur ti camp
mentis et opprimas meʒ opus ma
nuum tuarum et consilium im
piorum adiuues. Numquid ocu
li carnei tibi sunt: aut siaut uidet
homo et tu uidebis. Numquid sic
dies hominis dies tui et anni tui
siaut humana sunt tempora. vt
queras iniquitatem meam et pec
catum meum scruteris et scias
quia nichil impium fecerim: al
sit nemo qui de manu tua possit
eruere. ℟ Credo q̄ redemptor meus z
in nouissimo die de terra surrecturus

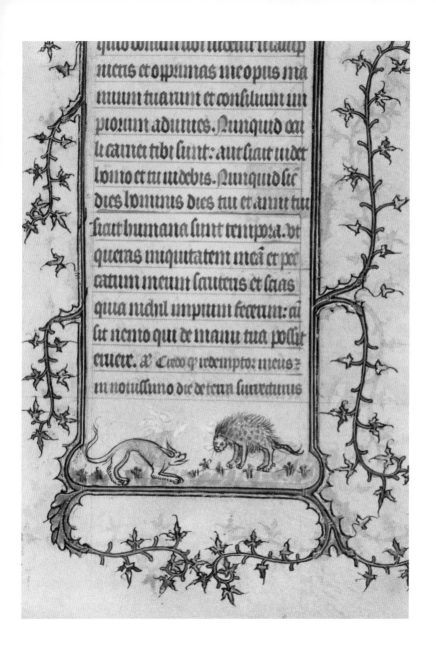

In medieval Europe, when cats
were considered in league with
witches—seems daft to say
that out loud now—a common
punishment was to tie the witch
in a sack along with her cat and
a heavy rock, and throw them
into a river.

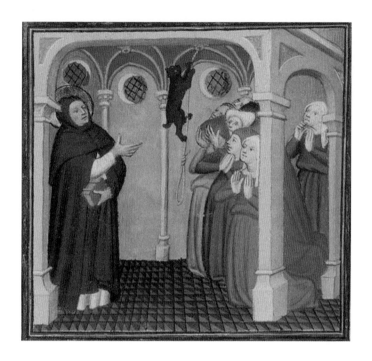

"As you can see, this black cat is clearly cursed!"

Cat climbs up a rope, The Hague, KB, 72 A 24, f. 313v, 1410.
From the Koninklijke Bibliotheek National Library of the Netherlands.

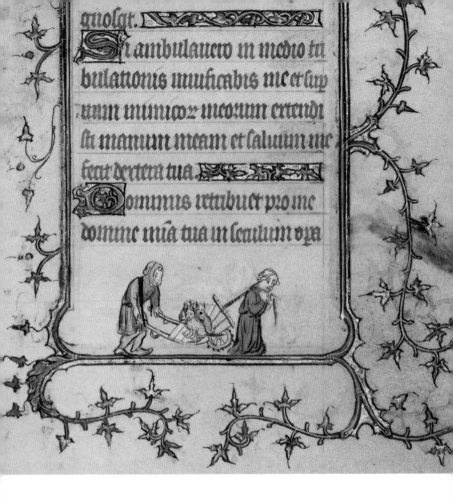

"Giddyup, humans! Faster!"

Humans carry cats, MS. Douce 62, f.129r, 1309.
© Bodleian Libraries, University of Oxford.

Six Cat Stats

1. Cats can jump six times their own length.

2. A cat's sense of smell is fourteen times stronger than a human's.

3. Cats have more than twice the amount of neurons in their brain as dogs (they're twice as smart).

4. Cats have twenty-four more bones in their bodies than humans.

5. A pet cat shares 95.6 percent of its genome with a tiger.

6. A modern cat's average lifespan is fourteen years. Medieval cats had an average lifespan of much less, around eight years (if they were lucky).

"I'm more of a dog person."

Agnes Waterhouse, from Essex, was the first person executed— by hanging—for witchcraft in England, in 1566.

Waterhouse made her innocence hard to be believed when she confessed to possessing a demonic spirit, a black cat called Satan. She blamed the cat for killing her husband after it told her to do it. Worst. Excuse. Ever.

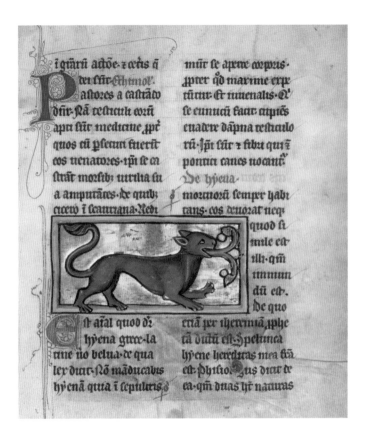

"Argh! The tongue's got the cat!"

Big cat tongue, De natura avium, *MS. Ludwig XV 4*
(83.MR.174), fol. 3, 1277. From the J. Paul Getty Museum Collection.

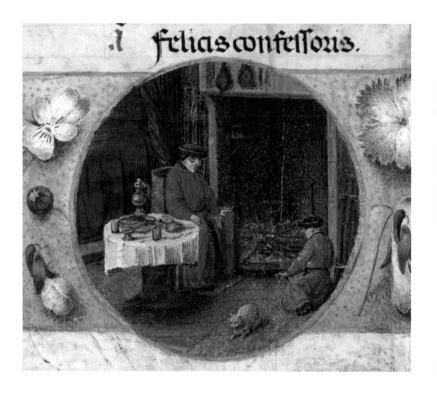

"Trip hazard or not, I've found the warm spot."

Cat warming itself before a fire, from Book of Hours (Rome), MS Add.
38126, f.1v, c. 1480. From the British Library archive/Bridgeman Images.

Witchcraft Act

In 1563, as superstitious suspicions of cats ran
amok across medieval Europe, the English
Parliament passed the Witchcraft Act.

This law stated that witches who were convicted of
killing a person—more often than not, their husband—
were to be hanged, often without a fair trial.

*"That butt better be clean.
I've got to lick that fur later."*

500,000

The estimated number of witches and pagans—85 percent of whom were women—condemned to die by hanging, drowning, or burning up until 1650 in medieval Europe, as a result of receiving convictions for witchcraft.

A clowder of cats, Littera textualis, *a didactic miscellany, containing a bestiary, MS Kk.4.25, f.74v, 1230. Reproduced by kind permission of the Syndics of Cambridge University Library.*

quas tergo laxacas emittit: quando canes
in sequetes parcur. quarum aculeis in
pbitace subsequentiu repellit.

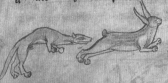

Cuniculi genus agrestium animaliu
dicti: quasi canicul. eo quod canum
in plagine captant. Furo a furuo dicit.
Unde & fur. Bestiola est que cuniculos de ca-
uernis perturbat.

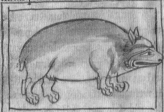

Melo dicitur uel quod sit rotundissimo
membro uel quod fauos petat. & assi-
due mella captet. De pelliculis uero melo
num fiebat prius indumentum quoddam
ad opus extreticium apud: quod melote
dicebant. Postmortu de pelle extrema factu
peram uotabant. Uestis est a collo pendens
& precinxta usq; ad lumbos. Melo qui &
alio nomine taxus dicetur. eo quod acerri
mum sit animal. huius axungia contra
guttam ualet.

Musio siue murilegus appellatus quod muribs
sit infestus. hunc uulgus cattum. a cap-
tura uocant. Alii quia captat id est uidet.
Nam adeo acute cernit: ut noctis tenebras su
su superet. Unde & a greco uenit cattus: idest
ingeniosus. apo tocatea. hic cu stomacu
cibo pregrauatu senserit. festucas carpit.
ad glutin. ut uel ita uomitu prouocet.

Mus pusillum animal grecum illi nome
est. Quicquid uero ex eo trahit tamin sit
Alii dicunt mures quod ex humore terre nas
cuntur. Nam mus terra. Unde & humus
Hiis in plenilunio iecur crescit: sicut que
dam martima augentur: que rursum
minuente luna deficiunt. Sorex latinu
est eo quod rodat. et in modum serre
precidat. Antiqui aute sorece sauice dice
bant sicut clodum: et claustum.

ut sciamus hunc a
mare. Et quo loco tu
locaris nos dignetur
collocare: In hoc eni
tu bearis cū tu potes
nos beare. Ignis
rubū ingreditur, rubꝰ
igne non leditur nec sol
um offenditur moyses
hunc aggreditur heret
stupensꝗ redditur sed
vox diuina subditur rei
ꝗ causa panditur. Tandē

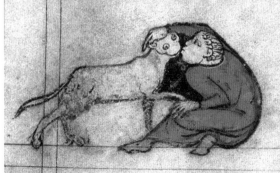

Caterwauling

The term used to describe the shrill, wailing sound a cat makes when it's in pain, lost, or pissed off at its owner for not being fed in a timely manner. From the Middle English term *caterwrawen*, "to cry like a cat."

"Someone's licked their bottom recently, haven't they?"

Man and cat kiss, Book of Hours, *Marginalia, Cambrai, France, Walters Manuscript W.88, fol. 40r, 1300. From the Walters Art Museum, Baltimore.*

Vibrissae

The scientific name for whiskers. Cats have twenty-
four whiskers in total, twelve per cheek. Without
them, cats can lose all sense of their surroundings.

"Ready, aim . . . FIRE!"

Cat pounces for a bird, Biblia Porta, *France, U 964, f. 357v, c. 1275.*
From the Bibliothèque cantonale et universitaire, Lausanne, Switzerland.

etur ⁊ oze eoz lingua dolosa: qm ipi pascēt
⁊ accubabunt ⁊ ñ erit qui erterreat. Lau
da filia syon· iubila tu isrł: letare ⁊ exulta
in omni corde filia ihrłm. Abstulit dñs iu
dicium tuũ· auertit inimicos tuos. Rex
isrł dñs in medio tuj: ñ timebis malũ ult.
In die illa dicetur ihrłm noli timere. syon
ñ dissoluantur manꝰ tue. Dñs dꝰ tuꝰ
in medio tuj fortis· ipe saluabit. Gaude
bit sup te malitia in leticia. silebit ⁊ dilecti
one tua· exultabit sup te in laude. Nugas
qui a lege recesserant congregabo· qz er te e
rant· ut non ultra habeas sup eis obpbriũ.
Ecce ego interficiam dꝰ qui afflixerunt te·
in tempore illo: ⁊ saluabo claudicantē. ⁊
eam que electa fuerit congregabo. Et po
nam eos in laudem ⁊ in nomen. ⁊ omñ tā
confusionis eoz· in tpe illo quo adducā
uos. ⁊ in tmpe quo congregabo uos. Da
bo enim uos in nomē ⁊ in laudem omnibꝫ
ꝑplis tre: cum conuertero captiuitatem
uṁm coram oclis urîs. Explicit So
phonias ꝓpheta. Incipit ꝓlogus in
aggeum prophetam.

Heremias ꝓpha ob causam puerꝫ se
dechie regis· ut in hystoria libri sctī
palyꝑmenon indicatur· q̃ fidē ꝓ
missam nabugodonosoz regi chaldeoz

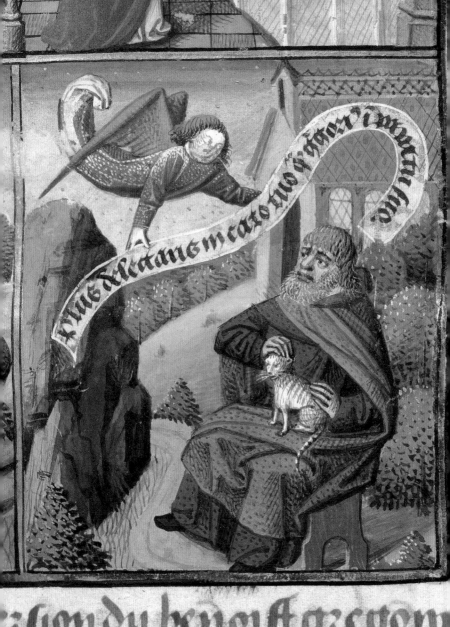

quis dileta me in caro tuo q̃ g̃ate i eo muda fide

ision du benoist gregoin

7.

NIPPETH & NAPPETH

ats can sleep with their eyes half-open, a fact that pretty much tells you everything you need to know about this creature. Can it be trusted? Or is it just waiting for its chance to strike? For centuries, humans have assumed cats were just lazy, but really they're just biding their time. . . .

There are an estimated 1 billion cats worldwide. Of which approximately 350 million are kept as pets, 500 million are stray or feral cats, and 150 million are wild big cats. America has the most pet cats, with more than 75 million.

"You better not be aiming for a bull's-eye!"

Archer takes aim at a cat licking its bum, Biblia Porta, France, U 964, f. 376r, c. 1275. *From the Bibliothèque cantonale et universitaire, Lausanne, Switzerland.*

sic regi ut mitteret eis exercitū in auxiliū. ⁊ tᵭe
teret ei regionē ⁊ cuutates coꝛ. ⁊ tributa. Et
mifit alios ī gazarā tollē iohem. ⁊ tbunis
mifit eplās. ut uenirent ad se. ⁊ darer eis arge̅
tum ⁊ aurū ⁊ dona. Et alios mifit occupare
ihlm. ⁊ monte tᵱlꝝ. Et ꝑcurrens qᵭā nū
ciauit iohi ī gazara. qⁱ pyr paᵗ eiˀ ⁊ fᵗes eiˀ.
⁊ qᵭ mifit te quoꝗ inᵗfici. Qⁱ audiuit aū ue
hemenᵗ expauit. ⁊ ꝯᵱhendit uiros quᵉ uenerat
ꝑd eū. ⁊ occidit eos. Cognouit eni. qⁱ qᵉrebāt
eū ᵱdᵉ. Et ceᵗa sermonum iohis. ⁊ belloꝝ eiˀ.
⁊ bonaꝝ uirtutum qᵇᵌ fortiᵗ gessit. ⁊ edificaᵗ
muroꝝ qᵉs exstruxit ⁊ ꝛeꝛū gestaꝝ eiˀ. ecce hec
scripta sᵗ in libꝛo dieꝝ sacerdotū eiˀ. ex quo
fᵗˀ est princeps sacerdotum post parᵗē suum.

Explicit liber machabeoꝝ pᵐˀ Inciᵱ sedˀ.

Fratriᵇᵌ qᵘ sᵗ
ᵱ egyptum iu
deis. salute di
cunt frᵉs qᵘ sᵗ
iherosolimis
iudei. ⁊ qᵘ ī regi
one iudea. ⁊ pa
ᵗ bonā. Bene
faciat uobis dᵒˢ
⁊ meminerit te
ᵗamᵗi sui qᵭ
locutˀ est ad abrahā ysaac ⁊ iacob seruo
rum suoꝛ fidelium. ⁊ det uob coꝛ omnibᵌ

"A group of three cats is called a clowder, right? But surely a *claw-der* is better?"

A clowder of cats helping (or hindering) a farmer, MS 16, 1475–1499, Bibliothèque municipale, Abbeville, France, 1475–1499.

132

Hypercarnivores

Cats are the only domesticated hypercarnivores in the whole world. Hypercarnivores are animals that require an absolute minimum of 70 percent meat in their diet.

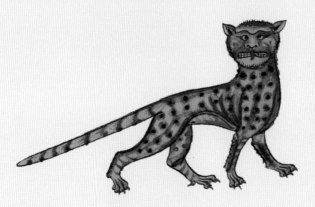

"Even humans look good enough to eat."

Clowder

The collective noun for a group of cats. A group of more than three cats is also referred to as a clutter, a glaring, or a pounce.

✧✧✧✧✧✧✧✧✧✧✧✧✧✧✧✧✧✧✧✧✧✧✧✧✧✧✧✧✧✧✧✧✧✧✧✧✧

A litter is the collective noun for more than three kittens, but the group can also be called a kindle or an intrigue.

"Come on, one bite won't hurt."

A pet cat plays with a mouse, Luttrell Psalter, Sir Geoffrey Luttrell, MS Add. 42130, f.190, c. 1335. From the British Library archive/Bridgeman Images.

es multitudini

runt ascendentes

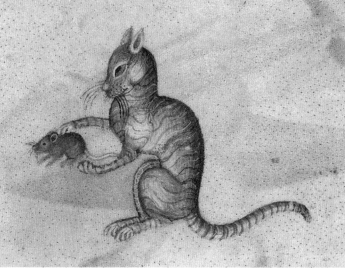

rapit spes eor̄ ḡpā q̄tate. In āīatib; bigñ
c̄. ut mul' ex equa ⁊ asino. burdo ex eq̄ ⁊ a
ex oue ⁊ yrcho. musino ex cap' ⁊ ariete.⁖ a

...vsio appel
...hunc uul
qd̄ captat.i. uidet.
luminis noctis ten
...c̄.i. ingeniot.

...us pusillū āīn
...latinū sit. Aliṅ
nascantur. Ham huius terra ⁊ m̄.i. his ū
q̄dā maritima augent̄ q̄ rurs' minuente

"Before I eat you, let me just
cough up this hair ball first."

A cat looks down on its dinner, bestiary, England, MS Add. 11283,
f.15, c. 1170. From the British Library archive/Bridgeman Images.

Dewclaw

The name of a cat's fifth toe on its front paws. It allows cats to climb to escape predators. Helpful for when a mob of pitchfork-waving maniacs wants to throw you into a sack and beat you to death for being a demon.

"My favorite pet? A trumpet!"

Cats are *digitigrades*— they walk on their toes, not their feet.

They also move only half their body forward at once, walking with both feet on one side first, followed by both feet on the other side. Females tend to put their right paws forward first and males tend to prefer their left. It's the reason cats look so elegant on their feet.

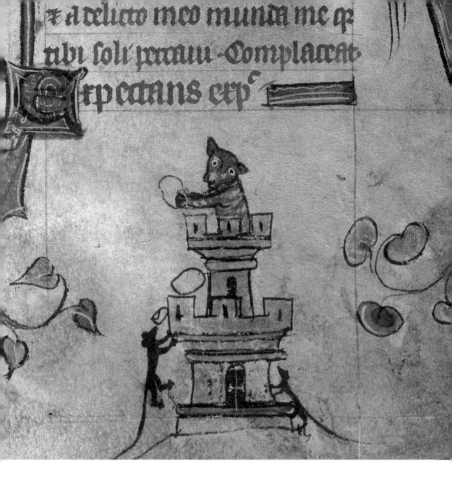

"A cat with a catapult is king!"

A cat in a tower aiming a catapult at mice, Book of
Hours, *England, Harley MS 6563, ff.71v–72, c. 1320. From
the British Library archive/Bridgeman Images.*

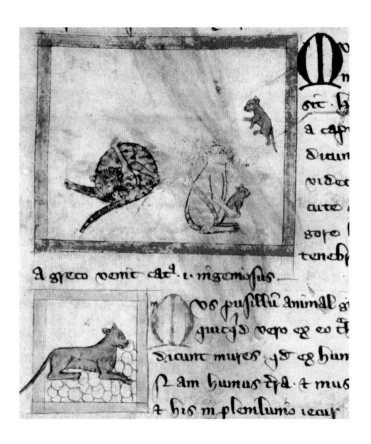

"Don't judge me. We all do it."

Cat cleans its bum as other cats look on, bestiary, MS. Douce 151, f.29v, 1300. © Bodleian Libraries, University of Oxford.

Frappuccino

A cat's "zoomies" were once considered a telltale
sign that it was possessed by the devil. Today
we know better. FRAPs, or frenetic random
activity periods, is the official term to describe
the intense but brief bursts of energy cats can get
during the evening. No one is quite sure why—it
could be to wake themselves up before late-night
prowling or to burn off energy after a catnap.

Isabeau of Bavaria

The fourteenth-century queen of France Isabeau of Bavaria, wife of Charles VI—the Mad King—loved her cat so much that in 1406 she spent an obscene amount of money—sixteen shillings!—on a tailor-made bright green cloth coat for it. Precisely the type of behavior that led to the French Revolution.

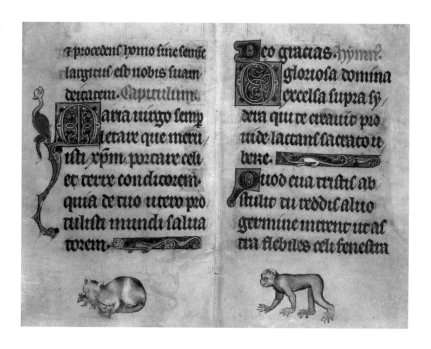

"Monkey see, monkey do."

The predator becomes the prey, The Harley Hours, England, Harley MS 92,8, ff.44v–45, c. 1275. From the British Library archive/Bridgeman Images.

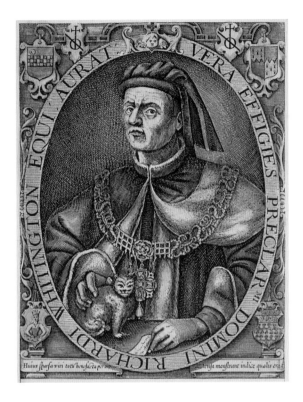

"Pose for a portrait?
Don't you mean *paw-trait*?"

*Richard Whittington with his cat, line engraving by Renold
Elstrack, c. 1700. From Granger/Bridgeman Images.*

Dick Whittington and His Cat

The most famous medieval cat owner was Richard "Dick" Whittington, London's Lord Mayor from 1397 to 1419. The legend of Dick Whittington tells the tale of a poor orphan boy who traveled to London to make his fortune with his rat-catching cat. Sadly, the real-life Whittington was neither poor, nor an orphan, nor owned a cat. Regardless, today a statue of a cat sits atop Whittington Stone at the foot of Highgate Hill, London.

"Time to give you some mouth-to-mouse resuscitation!"

Cat chases floor scraps, banquet scene, Ercole I d'Este Brevary, Biblioteca Estens, Modena, Italy, f.1, 1502. From © A. Dagli Orti/© NPL—DeA Picture Library/Bridgeman Images.

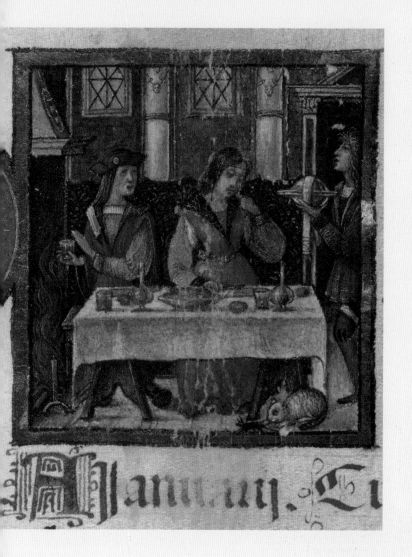

𝕴anuarij. 𝕰u

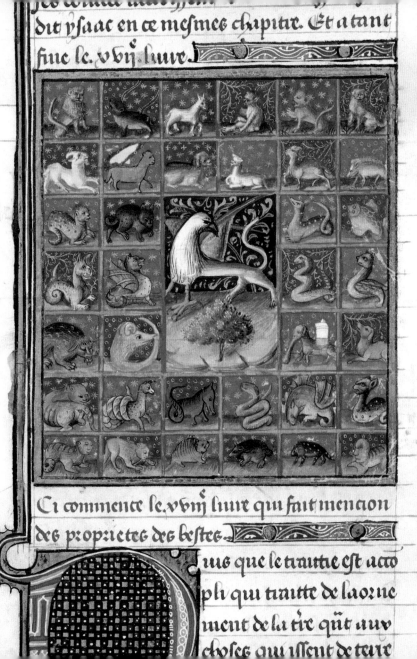

Ci commence le .vbiij. liure qui fait mencion
des proprietes des bestes.

ius que le traittie est acco
pli qui traitte de la ozne
ment de la tre qut auv
choses qui issent de terre

8.

CURIOSITY KILLED THE CATT

he thousand-year-long medieval era showed humans that cats are the most curious of creatures. They love to stick their whiskers somewhere they're not wanted or find a new toy to play with. Sometimes that means paying the ultimate compensation. . . .

Spot the cat, De proprietatibus rerum, *Bartholomaeus Anglicus, MS 399, f.241, 1240. Bartholomaeus; Liber. From Bridgeman Images.*

"Mouse, consider me
a *catastrophe*!"

Mouser in action—sort of, bestiary, England, c. 1250.
© *Fitzwilliam Museum/Bridgeman Images.*

Isaac Newton's Cat Problem

In 1687, while conducting his gravity-defining experiments at Trinity College, Cambridge, Isaac Newton frequently had to stop working as he was constantly getting interrupted by cats scratching at his door, wanting to come in. To stop the distraction, Newton asked a carpenter to cut two holes in his door—one for the mother cat and one for her kittens. It wasn't the first ever cat flap, but it did mean he could finish his work . . . and discover the laws of gravity.

Cats have the capacity to make more than a hundred sounds, from distinct purrs to signature screeches and hisses, grumbly growls to melodic mewing and meowing. Dogs can make only ten sounds. Idiots.

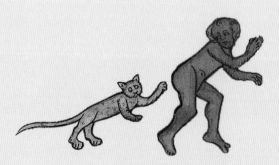

"The more you run, the more I have fun."

"Throw me a bone.
I haven't eaten in minutes."

Cat waits patiently for dinner scraps, Book of Hours, Bruges, c. 1500, MS Add. 35313, f.1v. From the British Library archive/Bridgeman Images.

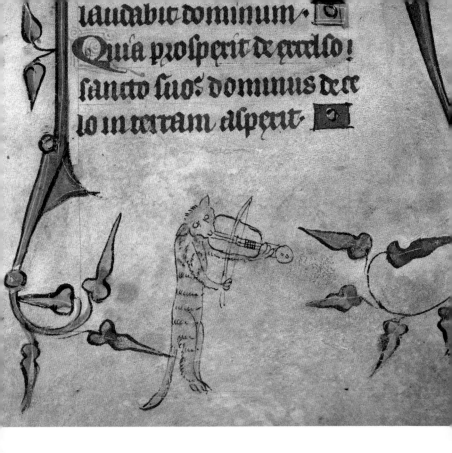

"It's better than my singing,
trust me."

*Cat playing a rebec, a popular bowed string instrument from the
medieval period,* Book of Hours, England, Harley MS 6563, f.40,
c. 1320. From the British Library archive/Bridgeman Images.

Catgut Your Tongue

In the margins of many medieval manuscripts, you'll find cats playing several stringed instruments. Scholars agree that this is a reference to catgut, natural fibers found in the walls of animal intestines, which were used for the strings of medieval musical instruments.

Cat Fact #2

One of the oldest inns in London, built c. 1500, was called Le Catt cum le Fydell (The Cat and the Fiddle). It was named after Catherine la Fidèle, the first wife of King Henry VIII.

The Old English word "catt" is believed to originate from the Latin word *cattus*, and first rose to popularity during the Dark Ages, around the sixth century.

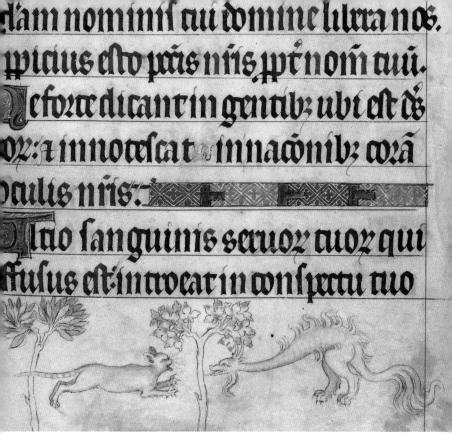

"Look what the cat
draggoned in."

Cat fights a dragon, The Queen Mary Psalter, *England, Royal 2 B. VII, f.188, 1310. From the British Library archive/Bridgeman Images.*

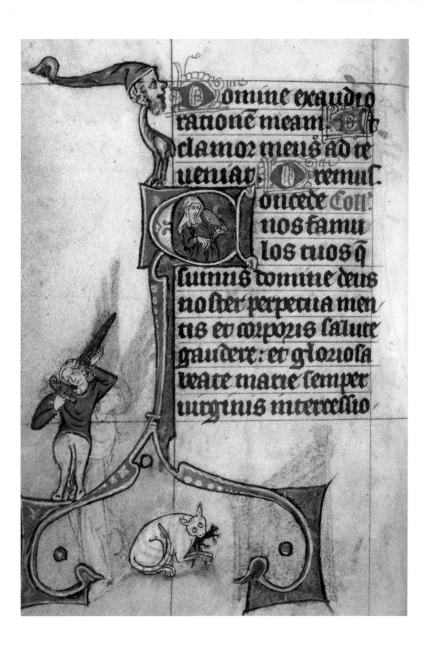

omine exaudi o
ratione meam. et
clamoz meus ad te
ueniat. Oremus.
oncede Coll
nos famu
los tuos q̃
sumus domine deus
noster perpetua men
tis et corporis salute
gaudere: et gloriosa
beate marie semper
uirginis intercessio

Piers Plowman

The first masterpiece of English literature from the period was the allegorical poem "Piers Plowman" by William Langland, written in 1370 (ish). In it, Langland explores the obstacles faced by those trying to live a life of virtue in late-medieval England. He does this by using cats as a metaphor for the tyrannical ruling class spreading fear among the rats—the working class. As such, cats, Langland writes, should be killed "for the sake of their skins."

"My cat breath is stinky. I need a mousewash!"

Cat cleans its teeth with a mouse, Book of Hours (Maastricht), Netherlands, Stowe 17, f.129v, c. 1325. From the British Library archive/ Bridgeman Images.

"Send not the cat for lard."

George Herbert, Church of England priest, c. 1600.

George's cat-calling was his way of making a particularly religious point: lead not your neighbor into temptation.

"I'm converting you all to Cat-holicism."

A cat with a bishop's crosier and miter taunts mice, MS Ludwig XV 1, 15th century. From the J. Paul Getty Museum Collection.

Quartus pedit pro formare in palatius z baculos pu...
...es qp quotab z portieb epm[?]... a meon z ad
pua se ircmare parerit z pbi fir obediens su...
pre reddit clang om ut mornar pagang...
mau fra reptas rent ergo mures z portieb...
eis fugietes in quo se latebris occultates z...
epmeb epistopatu deponut moralis bono...
mpro se pubdidisset qd ab eis doumo eu pell...
plus no poss gnare legis e se ptati alti[?] pub...
eli pob ne difficilis...

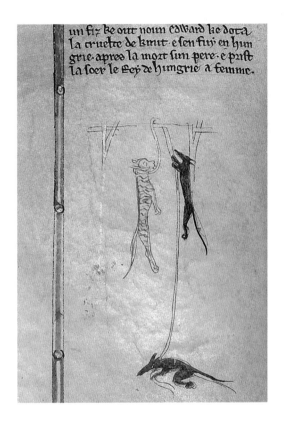

un fiz ke out noun edward ke dota
la cruelte de knut e sen fuz en hun
grie apres la mort sun pere e pust
la soer le sey de hungrie a femme.

"Hang in there, baby!"

Two mice executing a cat, Genealogical Chronicle of the
English Kings, *England, Royal MS 14 B V, 1275. From
the British Library archive/Bridgeman Images.*

Fain would the cat fish eat, but she is loth to wet her feet.

(The cat longs for fish, but she does not want to wet her paws.)

This famous cat proverb first appeared in 1562, but it gets a major doff of the cap in Shakespeare's *Macbeth* (1606), when in Act 1, Scene 7, Lady Macbeth calls Macbeth a coward for being unable to murder King Duncan. "Like the poor cat i' th' adage?" she says: Macbeth wants the throne, but he doesn't want to get his hands dirty in order to obtain it.

163

Rubbed the Right Way

Cats hate being rubbed the wrong way, but they do
love rubbing up against humans. A cat rubs its head
against people's legs as a way to mark them with a
scent emitted from the glands located on its head.
This is a territorial marking known as *bunting*.

∞∞∞

Cat Fact #3

Sixty bushels of grain—
The fine to be paid by anyone who killed
an adult cat per medieval German law.

∞∞∞

"Why did the cat cross the road? To prove he wasn't a chicken!"

A rooster and a cat square off, Claude Galien, Biblioteca Malatestiana, Italy, MS.d.xxv, c. 14th century. From Luisa Ricciarini/Bridgeman Images.

165

ectu dum conapiuntr:talem +fobolé pureat
ut.aialia mufu uenerio formac exuifecc̄.tuc
mittuut ut eorq̃ faciata typis rapit spēs
eox in ppriam q̃litatē.In animantibz bigeña di
cunt que ex diuifit nascuntr ut mulx ex eq̃ tas̄i
no.burdo:ex eq̃ + afina.Ibride ex aps +pocis.
tyri ex oue +hyrco.Mufiuo ex capia +ariete
ēst autem uix gregis.

"And where do you think you're going?"

Cats with runaway rats, bestiary, Royal MS 12 C XIX, f.36v, 1200.
From the British Library archive/Bridgeman Images.

"When all candles be out, all cats be gray."

("We're all the same in the dark.")

Thomas Heywood, *Book of Proverbs*, 1547.

Heywood was fond of using cats to make human points. He also famously wrote, "A woman hath nine lives like a cat," which is in no way biologically true.

ior sollicitudo · martirii tuo · īp
erat triplr · Sr eos qui ceuita
ria sollicitudo hēbat · p hiis am
cia ōs speraret iudiciu stim
erercitus erat ordinat · lestie e
o in lecto ꝓposita · Isidinis maca
tur die · r apricatū uaru arm
straz · Extendēc mans in cēlū
an iucauit · q̄ nō sm armo
tipi placr · dic dignus uictori
lj rio · Tu dūe q̄i musisti a
ia tege uitae · r infecisti de ea
u · dr̄ · Et nic dūator celoz mi
iū ante nos i timorez treīno
hu tuu · ur metiāt q̄ cū blas
diū sēm ꝑplin tuis · Et hiis
r hanoza · r q̄iu eu ipō era
mouebit · Iudas ito r qui cū
p ozōnes ꝯfessiote r gīsi siūt
nāce · sr dm coroibz orancib
ur̄ro · dr̄ · ꝓsencia dī magnī
cessassēt r cū gaudio redurit
ē eiusse cū armis siue · frō
cn ēe ciuitata ꝓita uite ōi
teebit · Precepit ā iudas q̄
ior ꝑ ciuibz ꝓnae eam cap
i cum buino abscisa ierosol

op mōstra · a in hiis q̄uoz gen
a ꝓncipio tercidm nō nega
tr̄ orco · nūc · dispō · ur̄ro · q̄o
z · qui fīez ex milite tec ꝫb leg
ꝑissi in carne · omnia in ꝯeua
ca in sem etiā resturgēs in co
pribz filio r filius nom plu ues
capto sn sine ostendēs unus se
cuio etiā glio utile z desidām
media ur̄ ꝓfea ꝯgnoscē · uer
uīglir r dilcērm dum carne
sa legēre intulligit · atqr id i
sist r apru endc exꝓdit ī cogn
studio arguīta fut r fidr fce
dī intullidam diligenti cē dis
Atlis · cū ꝓio fclicass e
iudea · uolēr tnistre ad g
scꝓsit hebraice r fiubz a cuiu
reliquid · Sic n · nctr fiut ap
glin fclicari sicr q̄ liticos r sch
uii scrꝑsmt q̄u ortin auct
ꝑ q̄cuoz muido ꝓter fidē nūc
st cī q̄cuoz uōte in q̄ diriga dc
diōm euuglia · r gēsibz in at
ꝫꝓntum eor erat scluē uui
cū euuglia dereidunt nec roi
uolebit ꝟsin m̄n iuim castal

9.

NINETH LIVETH

ine lives it is said a cat possesses. Alas, 'tis not true, sadly. Nor would cats care to live more than once. To a cat, life is not about purpose, meaning, or even being awake. It's about simply finding a moment and living in it for as long as possible, be it a warm lap, a furry friend, or a vermin to vanquish. If this book teaches us anything about life, it's this: be more cat.

White cat jumps across a column, Arras, France, MS Codex 724, f. 272v, c. 1200. From the University of Pennsylvania, Rare Book & Manuscript Library.

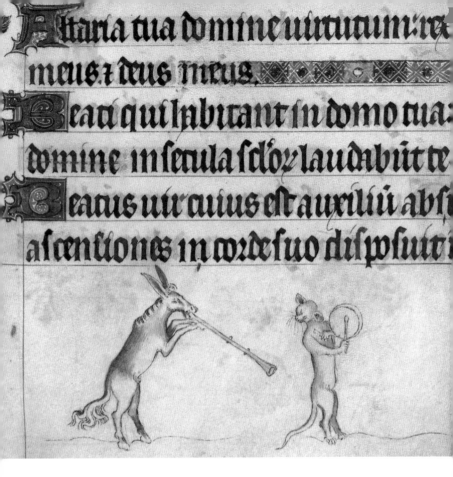

"Be quiet, you silly ass!"

Cat plays a tabor, a type of medieval drum, The Queen
Mary Psalter, England, Royal MS 2 B VII, f.194, 1310.
From the British Library archive/Bridgeman Images.

Ways to Skin a Cat*

The cruel practice of skinning cats for pelts was all the rage in the Middle Ages, even if knights were not allowed to be caught dead in them, according to the Sumptuary Laws of 1363.** Cat skinning has now been outlawed in America and Britain— but only since 2000 and 2007, respectively.

*FYI, according to research, twenty-four cats are needed to make a cat fur coat for an average-sized human.

**Cat furs were considered low quality and were only allowed for "esquires and gentlemen under the rank of knight with land worth up to £100 a year."

Ailouros

The ancient Greek word for "cat," meaning "the thing with the waving tail."

Like the ancient Egyptians, the ancient Greeks loved cats. The famed historian Herodotus noted in 440 BCE that in ancient Egypt, when a cat died, the entire family would enter into a deep state of grief and mourning by first shaving off their eyebrows.

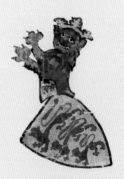

"Fancy a claws encounter?"

"Oh God, not another one."

Above: The Birth of John the Baptist and the Baptism of Christ + *cat, The Hours of Milan, Jan van Eyck, f.93v, 1422. From Bridgeman Images. Opposite: Cat coat of arms, Zürich armorial, AG 2760, f. 1r, Schweizerisches Nationalmuseum, c. 1340.*

Ailurophile

A lover of cats.

"Nothing can stop me now!"

Ailurophobia

A persistent and excessive fear of cats.

Tachotechnoailurophobia*

A terrifying fear of cats with jet packs.

*(Maybe.)

"This'll make my zoomies even zooooooomier!"

Rocket-powered cats, Ein wahres Probiertes und Pracktisches geschriebenes Feuerbuch, *V.b.311, f. 129r, Folger Shakespeare Library, 1607. Universitätsbibliothek Heidelberg, Cod. Pal. germ. 128, f.74r, 1535.*

A black cat, I've heard it said,
Can charm all ill away,
And keep the house wherein she dwells
From fever's deadly sway.

Welsh folklore rhyme

◇◇

In Celtic mythology, black cats were sacred creatures.
Scottish folklore told of how a black cat's arrival
at a new home signified prosperity, and Welsh lore
stated that a black cat brought only good health.

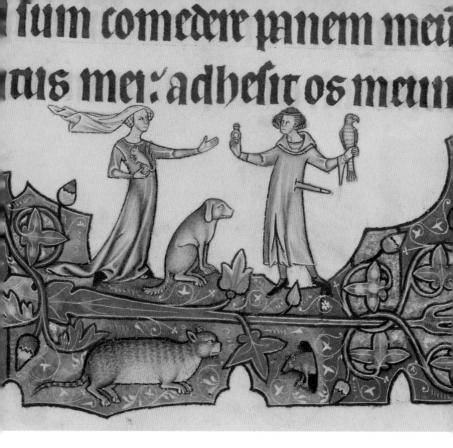

"A mouse that has but one hole
is quickly eaten!"

Cat hunts mouse into a hole, Ormesby Psalter, *MS. Douce 366,*
f.131r, 1250. © Bodleian Libraries, University of Oxford.

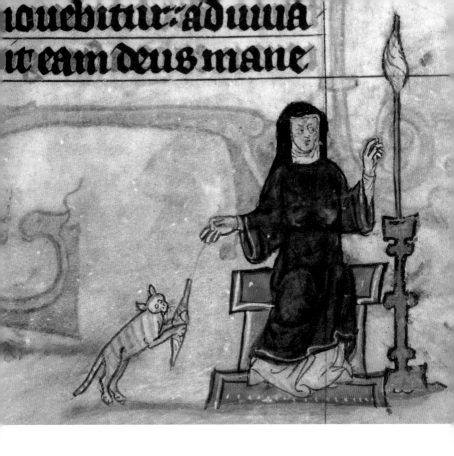

"I DEMAND THE STRING NOW!"

St. Gertrude of Nivelles, portrayed as a nun, with a spindle and a cat holding wool, The Maastricht Hours (Netherlands), MS Stowe 17, f.34, 1310. From the British Library archive/Bridgeman Images.

The Wife of Bath

Thou said this, that I was like a cat;
For if anyone would singe a cat's skin,
Then would the cat well stay in his dwelling;
And if the cat's skin be sleek and gay,
She will not stay in house half a day,
But forth she will go, before any day be dawned,
To show her skin and go yowling like a cat in heat.

Geoffrey Chaucer, "The Wife of Bath," The Canterbury Tales, *c. 1400.*

This is one of the most famous tales from *The Canterbury Tales* and one in which a wife, Alisoun, explains to the reader that her ex-husband once compared her to a cat. It goes on a bit.

William Baldwin's 1553 *Beware the Cat* is claimed to be the first novel ever published in English. It is filled with fantastical tales of talking cats, witches disguised as grimalkins, and a cat-court run by deliberating felines. It's also an anti-Catholic satire that criticizes the cruel religious treatment of cats during the late medieval period. The title's ironic, then.

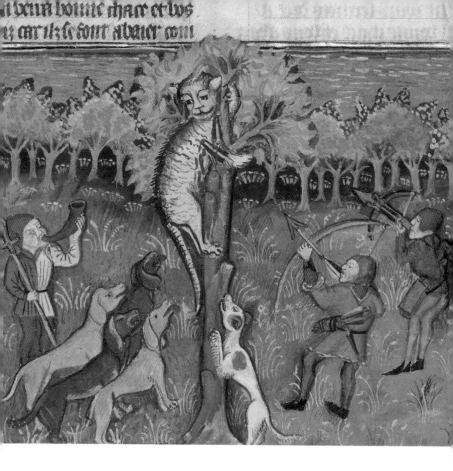

"Dogs and arrows? That's overkill, guys."

Cat stuck up a tree, the Book of the Hunt, MS 27, f. 97,
87.MR.34.97,1430. From the J. Paul Getty Museum Collection.

"Let me out!
I'm claws-trophobic!"

Friendly cat, The Aberdeen Bestiary, *MS 24, f.8v, 1200.*
From University of Aberdeen Library.

"The devyl playeth ofte with the synnar, lyke as the catte doth with the mous."

("The devil plays with our souls, like the cat plays with the mouse.")

William Caxton (not a cat person), pioneer of the printing press, The Royal Book, *1484.*

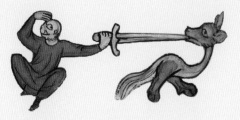

"You've got something between your teeth."

Cat Síth

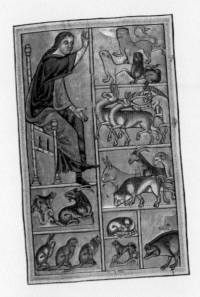

The origin of the expression "cats have nine lives" dates back to Celtic mythology, around 700 CE, and the wicked creatures known as Síth cats. The Celtics believed that these large black cats, with a stroke of white fur on their chests, were witches with the ability to transform into a cat nine times during their life. In cat form, the Síth used their sorcery to steal the souls of recently deceased humans, robbing them of the chance to ascend to Heaven. The myth of the Síth was inspired by the increasing hybridization of wildcats and domestic cats found in Scotland during the early medieval age.

"Cats at the back,
pay attention, please."

*Jesus talks to the animals (the cats aren't listening), The Aberdeen Bestiary,
MS 24, f.2v, f.5r, and f.23v, 1200. From University of Aberdeen Library.*

Above: Cats, lions, and a dragon, Leonardo da Vinci, c. 1517. From the Royal Collection Trust/© His Majesty King Charles III, 2024/Bridgeman Images.

Opposite: A young boy with a cat, Leonardo da Vinci, F 263 inf. sheet 89 recto, 1495. Gift of Charles Rosenbloom/Bridgeman Images.

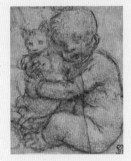

"I decide when the cuddle's over. Got it?"

"Even the smallest feline is a masterpiece of nature."

Leonardo da Vinci, Italian painter, engineer, scientist, theorist, sculptor, architect, all-around genius, c. 1530.

Leonardo da Vinci absolutely adored cats. When he was not busy reinventing the wheel, Leonardo drew loads of sketches of kitties at play. Sadly, none of these drawings were completed as paintings.

erapsic wracit tinuit ex oue thurco nuttis moe
capta ta auete. et autem dur ggit.

uio applatur ex unnttbz nteetut set
hut uulguicattum acaptura uo
cant. Alij dut ce captat. 1. nudet uanttan
to acitte cernit ut fulgore lu
nunut uotut tenebzat super
unde agto uenit cattut. 1. in
geniosus.

oc puellum animal geum nomē
est. quicetund uelo exeo trahit lati
num fit. Alij dicunt muritel q per humoze
terre nascantur. Nam mus
tra tn mnuib hic tn plenilunio
retur crescit ut ut quedam ma
ritima augetur cue uirtut
tn singue tte uilla detatunt.

alpa ducta ce sit damata cecitate ppe
tua tenebut. et tenut abscp ocilisep
tum sodithi numum egerit. tradicel cube
frugibz comedit quod gra
alphala uocat.

nuum d nome anium.
Sp gsit ductum. nam
sit ille sibi diffunt uarnate
diuitate. nam alie simplices sunt ut col
uunbe pa scute ut pdix. alie ad manium se
ibuuuunt ut auctipitres. alie reservdaut

queco discer
tao sublin
luces ano
uitate dic
pedic suer
quaum n
pulli dut
quadupec
uus pullu
sunt. uitu
quibz pen
usum. uoca
actoueatt
uolando du
pennax au
dantt plum
quadruped
uu nome
opista ut ga
ulula cuculu
ta semut u

ulfa
tcat n
cipitel uiolat
t uttra mar
ciunt. Alcu
tet multa
sautttate cel

10.

THE CATT OUTTETH THE BAGGETH

anding on their feet at the end of the medieval era, cats were quick to lord their torturous treatment all over us. Never again would they find themselves stuffed in a sack, drowned in a river, burnt to a crisp, or skinned alive by sorcerers. The cats were once again out of the bag, back in charge, and living large. . . .

Cats love a good box, Dares Phrygius, "History of the Trojan War,"
Alexander Neckam, "De nuptiis Philologiae et Mercurii fabula,"
R.14.9, f.100r, England, 12th century. From the Master and Fellows of
Trinity College and Trinity College Wren Library, Cambridge.

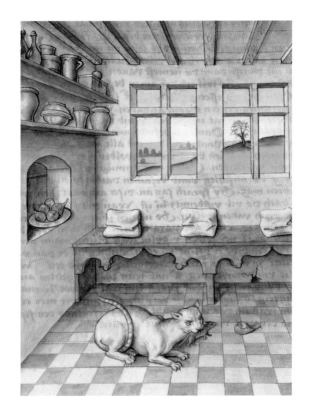

"Any mousehole's a goal!"

A cat catches a mouse outside a hole, The Fables of Bidpai,
MS 680/1389, f.96, Württemberg, Germany, c. 1480.
© Musée Condé, Chantilly/Bridgeman Images.

Medieval Dates for Your Diary

525—The invention of
the Anno Domini calendar

717—The Siege of Constantinople, the most
important military conflict of the Middle Ages

800—Charlemagne crowned emperor of the Romans

919—The first use of gunpowder

1066—The Battle of Hastings, and the
Norman conquest of England

1095—The Crusades begin (and go on for ages)

1215—The signing of the Magna Carta, the
beginning of the end for the powerful monarchs

1347—The onset of the Black Death, the largest
pandemic in human history; 200 million dead

1439—Johannes Gutenberg invents the printing press

1492—Italian explorer Christopher
Columbus sets sail for the Americas

The medieval era, or Middle Ages, is
subdivided into three distinct periods:

Early—sometimes referred to as
the Dark Ages—from 475 to 1000

High—from 1001 to 1300

Late—from 1301 to 1500

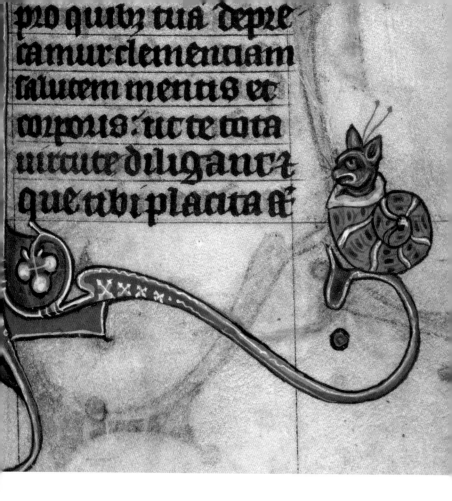

"Snug as a cat in a hat."

Cat snail, Book of Hours (Netherlands), Stowe 17, f.185, 1310.
From the British Library archive/Bridgeman Images.

"Have a good poke around,
why don't you."

Cat stabbin', bestiary, MS. e Mus. 136, c. 1275.
© Bodleian Libraries, University of Oxford.

"They delight in being stroked by the hand of a person and they express their joy with their own form of singing."

Thomas de Cantimpré, on why cats purr, De natura rerum (On the Nature of Things), *1270*.

"Game over, rodent!"

"Take the gull of a male cat, and the fat of a hen all white, and mix them together, and anoint thy eyes, and thou shalt see it that others cannot see."

Albertus Magnus' recipe for a "magical" cat potion, The Book of Secrets, c. 1245. Albertus had many other "remedies" that involved cats, including rubbing a cat's tail in your eye to cure a stye. It doesn't work. We tried.

"Eight lives left."

Startled cat chased up a tree by a pack of dogs, MS. Ludwig XV 1, f.44, 83.MR.171.44, France, 1500. From the J. Paul Getty Museum Collection.

Homo volens i nauicla brachium mari[?]
dcū rogabat ut ei assisteret z ad opta[?]
ceret medio a via sua irruit i nauicula[?]
assere cepit z ille trepidare Rogauit ergo[?]
unde eripuit cū i mittet pd tū cōso i miso[?]
obuiacibg vndis z impeditus [?]ue ergo des[?]
te litus venire possit ait ad dmm fac mim[?]
tate tua ex quo facere mea nō vis z sto[?]
Tpulsis flatibg i optato litā e gratitus [?]
dm voluntate suā dīni pubraret volutati[?]
nim i periculis a deo nō delinqm

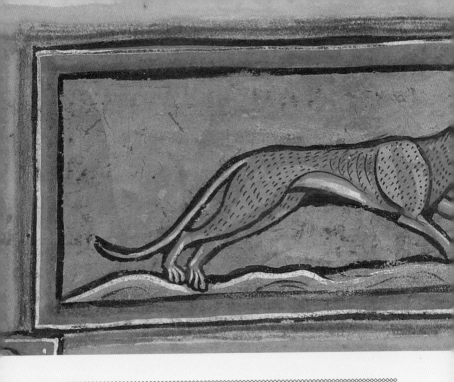

Cat Fact #4

America's "first" pet cat breed—the American shorthair—
is descended from the cats that traveled on the
Mayflower with the British colonists in 1620. The cats
aboard the ship, en route to Cape Cod, were employed
to keep rats and mice away from food rations. Once
the ship arrived, the cats were free to live in the land
of liberty and be witnesses to the birth of the nation.

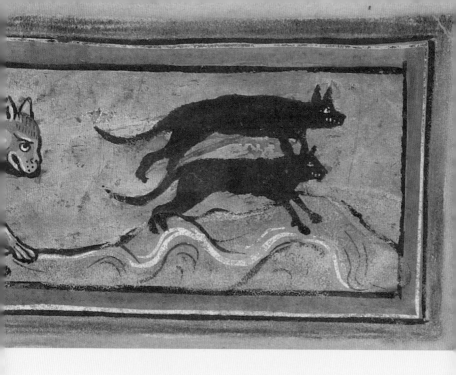

"Two for the price of one!"

Cat chasing mouse (with a mouse on its back), bestiary (Rochester), England, Royal 12 F.XIII, f.43r, c. 1250. From the British Library archive/Bridgeman Images.

Cats versus Dogs

The phrase "fighting like cats and dogs" dates back to at least 1611 but is likely much more medieval in origin. Shakespeare (him again!) certainly knew of their disdain for each other. In his tragedy *Hamlet* (1603), the titular hero mutters, "The cat will mew, and dog will have his day" (Act 5, Scene 1).

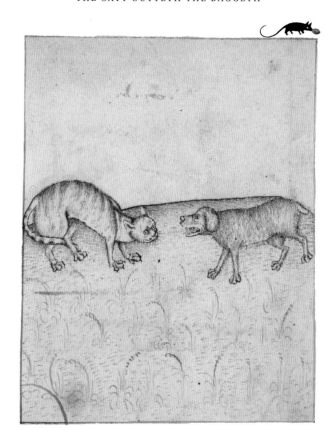

"Your dog days are over, mate."

To Agree Like Cat and Dog, *Léon Gruel, Savoy, France, W.313.30R, 1490. From the Walters Art Museum, Baltimore.*

lectationes n

a usq; in fine

luntatem tu

cum . ut clar

Nepeta cataria

The Latin name for catnip, a perennial herb in the mint family. Catnip contains a chemical called nepetalactone that hilariously affects a cat's behavior when ingested or rubbed into fur. When high, cats enjoy a fifteen-minute period of intense zaniness and drooling followed by equally intense sleepiness.

"Here come the tickle paws!"

A cat playing with its kitten, Psalter, MS Ashmole 1525, f.014r, c. 13th century. © Bodleian Libraries, University of Oxford.

"Whenever thou sits to eat at the table, avoid the cat on the bare wood, for if thou strokes a cat or a dog, thou art like an ape tied with a lump of wood."

James Orchard Halliwell, The Boke of Curtasye
(The Book of Courtesy), *1475.*

By the fifteenth century, cats lived indoors with their owners. But allowing the cat near the dining table while humans ate was still regarded as the height of bad manners, according to medieval codes of social etiquette.

"Your breath smells
worse than mine—and I've
been licking my butt!"

Cat kissing, Book of Hours (Rome), MS B. 11. 22, f.38r,
*c. 1440. From the Master and Fellows of Trinity College
and Trinity College Wren Library, Cambridge.*

"I don't need the devil to possess a human— I can do that all by myself."

Evil cat, bestiary, CCA-LitMs/D/10 fol. 11r, c. 1300.
© Canterbury Cathedral/Reproduced courtesy of the
Chapter, Canterbury Cathedral/Bridgeman Images.

> *"Dryve out dogge and catte,*
> *or els geve them a clout."*

John Russell, The Boke of Nurture, 1460.

<hr />

It is clear from John Russell's well-read publication,
The Boke of Nurture, that as the medieval era ended,
pets were still not allowed to sleep—or even enter—
the bedroom of their owners. Perhaps Russell's
quote is the origin of the idiom "kick the cat"?

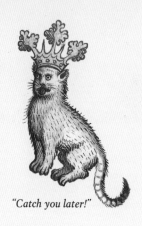

"Catch you later!"

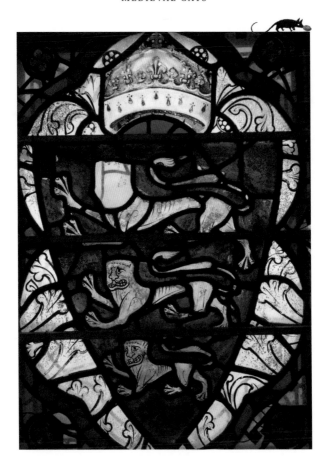

Three lions on a church, Salisbury Cathedral, Wiltshire, England.
This famous cathedral was built in 1220 and houses one of
only four surviving copies of the Magna Carta, one of the most
important documents created in the medieval era, c. 1215.